WALWORTH
THROUGH TIME

Mark Baxter
& Darren Lock

AMBERLEY PUBLISHING

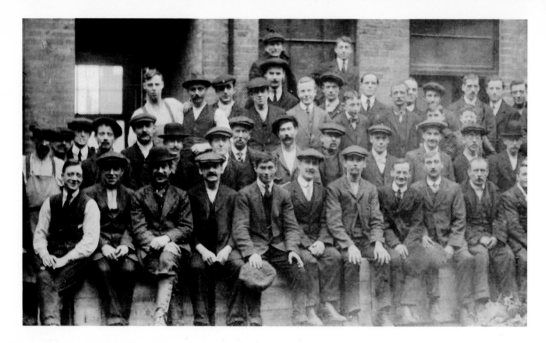

Draymen, Weymouth Street *c.* 1919

The draymen above have long gone, as has indeed Weymouth Street. This photograph like so many of those contained in this book has come from the people of the Walworth community. They have come from the people who live in these streets; they have come from people who have moved out of the area but who are still drawn back to visit where they grew up and they have come from people who have heard their parents and grandparents talk over the years of the 'good old days' there. These images, many never seen before, accompanied by those from the local history library in Southwark plus photographs taken in 2010, give a fascinating look into its past, as well as documenting the present in this extraordinary part of London.

First published 2010
Reprinted 2011

Amberley Publishing
Cirencester Road, Chalford,
Stroud, Gloucestershire, GL6 8PE

www.amberley-books.com

ISBN 978 1 4456 0163 2

British Library Cataloguing in Publication Data.

A catalogue record for this book is available from the British Library.

Typeset in 9.5pt on 12pt Celeste.
Typesetting by Amberley Publishing.
Printed in the UK.

Introduction

The area of Walworth, London SE17, lies south of the River Thames and is a hustling, bustling area with a historic past.

Its boundaries are the Elephant and Castle in the north, Kennington to the west, Camberwell to the south and the Old Kent Road in the east.

Looking at the area today, it's very hard to ever think of Walworth as anything other than an urban cityscape, lined as it is by the concrete blocks of the Heygate and Aylesbury housing estates, erected in the early 1970s on demolished and bomb damaged wasteland. Shops of every sort line the main route through it, the Walworth Road: once a cart track that cut through the Walworth Common.

By looking into its past, we find the Romans knew of the location, as did the Anglo-Saxons. The latter named the area Wealawyrd or Waleorde, which translates into 'The Farm of the Britons' with Walworth, as it became, famous for its market gardens and orchards.

The area is mentioned in the Domesday Book of 1086, which describes the village life of the manor with corn growing in the fields and cows grazing on the meadowland.

It is said that a later inhabitant of the village was Sir William of Walworth, who became the Lord Mayor of London between 1373 and 1379. In 1381, Sir William mortally wounded Wat Tyler; the leader of the Peasants' Revolt of that year, as Tyler and his army marched into London. To mark this event a dagger was added to the coat of arms of the City of London.

This book will examine a more recent past as London grew from the 1800s, spreading across the River Thames as new bridges were built, with Westminster Bridge being completed in 1750, and improvements made to London Bridge around the same time. This, coupled with farmland gradually disappearing and grand houses being built on the land, resulted in Walworth becoming a very desirable suburb, with its gentlemen travelling into town, echoing the commuters of today.

Among the usual high street shop names you'll find on the Walworth Road, you'll also find one or two older local establishments that have traded here for many years. Arment's Pie & Mash shop for example, established in 1914 and Baldwin's the herbalist health shop that began even earlier in 1844. There has also been a bespoke tailor at number 187 for at least eighty years.

At the half way point on the road, you'll find East Street Market, known locally as East Lane or simply 'The Lane'. The street market has been here officially since 1880, though trading occurred nearby in the surrounding streets for many years previously to that.

Notables associated with SE17 include silent film legend Charlie Chaplin, born over a shop on East Street in 1889, a fact commemorated by a plaque on a wall at the mouth of the market. Others include Maurice Micklewhite, better known to millions as film star Michael Caine, and Charles Babbage, considered by many as the originator of the modern computer.

Walworth has constantly changed over the decades: it never stands still and the influx of people from around the world who have settled in the area continues a trend started in 1840 with the arrival of the Irish immigrants escaping the potato famine of that year. Before long the majority of 'well-to-do' residents were moving out and ten families were moving into houses built for one, resulting in severe over-crowding and slum conditions.

In the 1920s and 1930s, a quarter of all housing in Walworth was considered unfit for human habitation, and the demolition of these properties, coupled with the Second World War bomb damage caused to that still standing, left town planners with a clean slate when it came to the building of new homes.

Their answer to this problem was the construction of enormous council estates, namely the Heygate and the Aylesbury.

Now, not fifty years after they were built, the entire Heygate estate buildings are due for demolition as part of a major regeneration programme planned for the Elephant and Castle end of Walworth, with 6,000 new homes planned. With substantial renovation also planned for the Aylesbury estate, once again this area is undergoing massive change.

So will begin another chapter for this famous district of London.

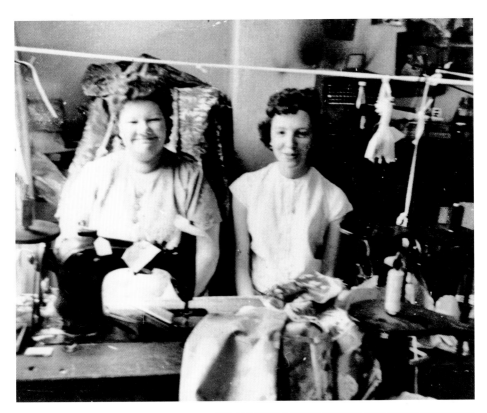

Boundary Lane *c.* 1955

As the name implies this marks a boundary line to the area of Walworth, with this being in the south – at the Camberwell end. For many years small factories operated here, and the photograph above shows the workroom of the Jacob's clothing factory. The company made dresses, skirts and blouses for central London stores and all the workers were local to the immediate area. Of the majority of the buildings that remain there today, most are now private dwellings.

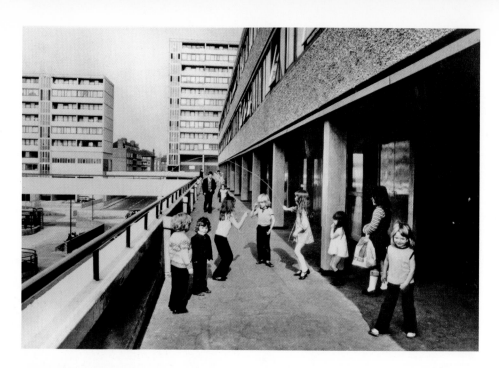

The Aylesbury Estate *c.* 1971

Designed by architect Derek Winch and covering an area of over 28 hectares, construction on the Aylesbury Estate started in 1963. The 2,500 flats housed a population of approximately 10,000 residents, making it the largest public housing estate in Europe. Finally completed in 1977, it included a nursery and a health centre. The various housing blocks were named after towns and villages in Aylesbury, Buckinghamshire. An extensive re-building and regeneration programme for the estate began in 2009.

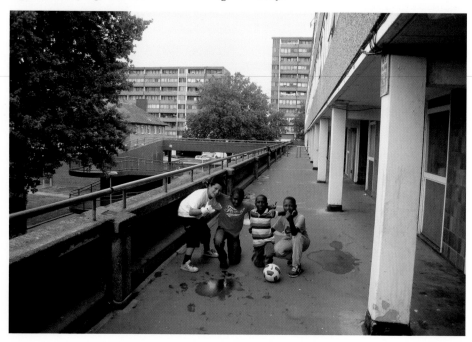

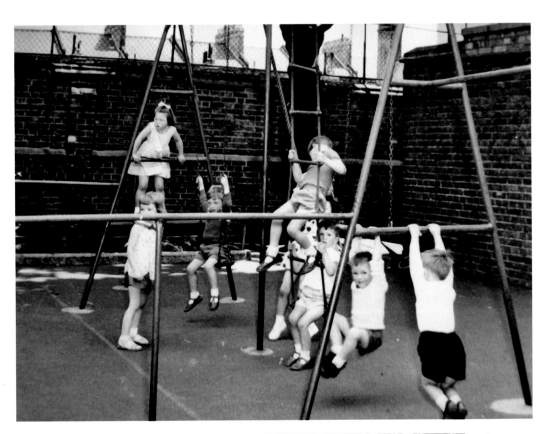

Surrey Square Junior School *c.* 1962
Situated between the Aylesbury Estate
and the Old Kent Road, the school has
stood here since 1844. A group of pupils
enjoy time in the playground in the
early 1960s and a happy and energetic
school is still in place today. In 2008
the staff and pupils took an active part
in the 'Charlie Chaplin's South London'
book project, which told the story of
Chaplin's experience as a schoolboy in
Walworth in the early 1900s.

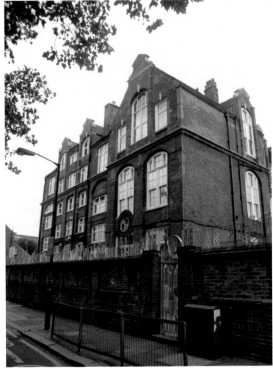

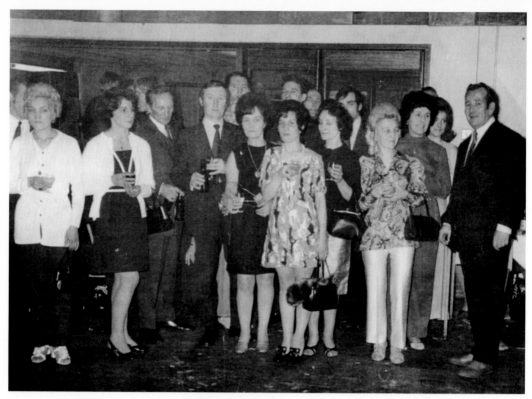

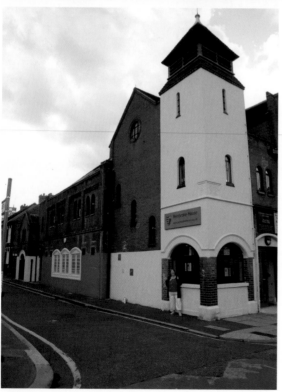

Pembroke House c. 1967
Founded by students of Pembroke College Cambridge, in 1885, its aims were to provide a social centre for the poor of the area. It is also home to St Christopher's Church with the buildings on Tatum Street, near to the Old Kent Road. The club is still going strong today and is home to many activities from a youth club to local dance groups, as well as being a popular venue for those looking for a night out over the years as can be seen from the photograph above taken in the club in the late 1960s. St Christopher's Church is part of the Anglican Diocese, and is Grade II listed. Designed by Edward S. Prior and completed by Herbert Passmore in red brick with a slate and tile roof. Overall, the buildings are a rare surviving, virtually intact, example of an 'Oxbridge' mission from the nineteenth century.

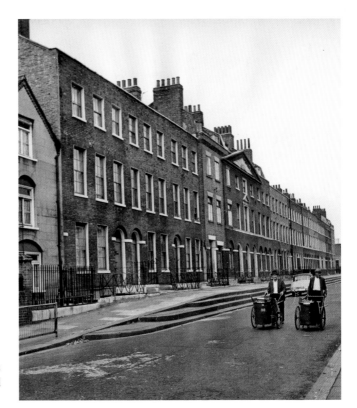

Surrey Square c. 1964
A fine selection of Georgian terraced houses designed by surveyor Michael Searles and built between 1795 and 1796, eighteen of which have survived. The buildings today still have their original torch snuffers and railings and the 'four-kerb' pavement is also an interesting feature. The fan motif pediment in coade stone above the end pavilion is another original surviving detail. Samuel Palmer, the well-known landscape artist, was born at number 42 (formerly number 13) in 1805.

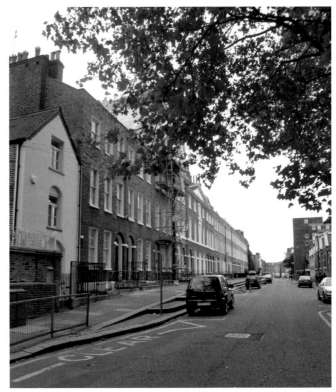

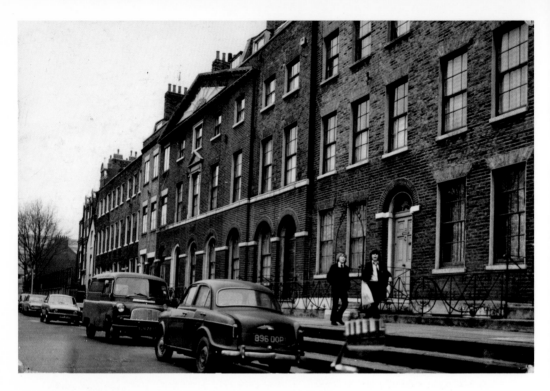

Surrey Square *c.* 1973

Michael Searles, (1750–1813) was also a favoured surveyor for the Rolls Estate, which began in 1775. John Rolls, a cow keeper, rented ten acres south of the Old Kent Road. Gradually he acquired other valuable land locally and also in nearby Bermondsey. His descendants included Baron Llangattock who was the father of Charles Stewart Rolls. In 1904, Charles began a partnership with Henry Royce resulting in the Rolls-Royce Company being formed in 1906.

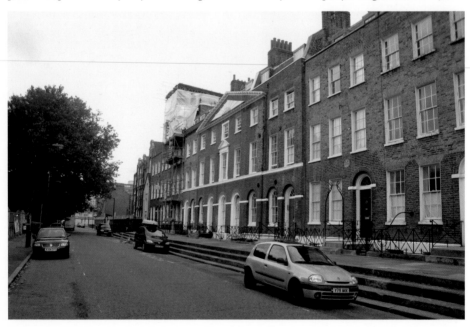

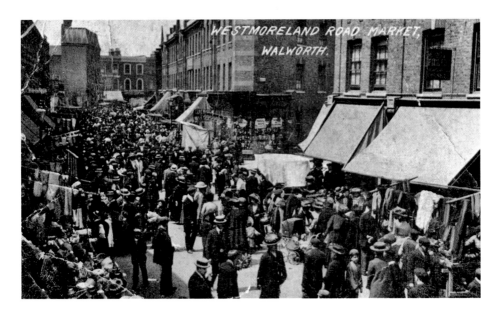

Westmoreland Road *c.* 1922

For well over a hundred years there has been a market in this otherwise quiet side road. It drew 'totters' – better known as rag and bone men, from all over London to sell the old clothes they had collected on their rounds. This tradition continues on Sunday mornings still drawing in a decent crowd. Alongside the clothing stalls, a variety of electrical goods and a jumble of bric-à-brac can be also purchased. Once part of Walworth Common it was also home to The Newington Institute Workhouse for the poor and destitute, which was built in 1885 and which housed up to a 1,000 people when it first opened. Described as a tall, grim building it was demolished in 1969. Among its residents for a short while, were a young Charlie Chaplin and his brother Sydney. The Arment's Pie & Eel shop is situated at numbers 7–9.

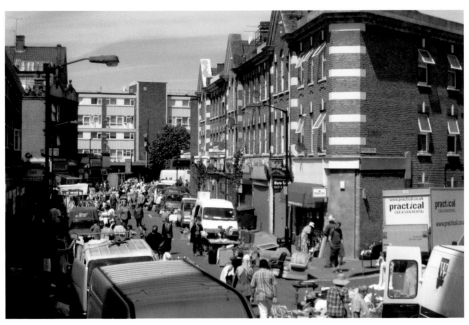

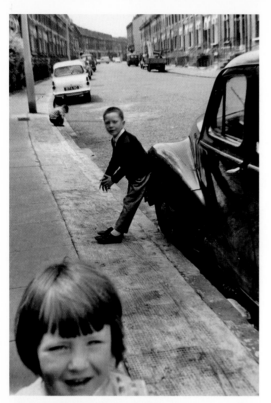

Boyson Road *c.* 1964
Behind the children playing in the foreground can be seen the sweep of nineteenth century housing that once formed Boyson Road, here seen leading towards the Walworth Road. Once part of the Walworth Common estate, the majority of the housing was demolished to make way for the Aylesbury Estate, construction of which started in 1963. Today, very little of the old road named after Ambrose Boyson, a noted Victorian magistrate, survives.

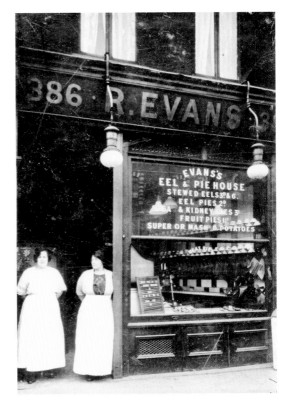

Evans' Eel & Pie House *c.* 1913/1994
Arment's Pie & Mash is famous
throughout the area of Walworth for
its handmade steak pies, which are still
made from a secret recipe. The Arment
family bought the business from the
Evans family in 1914, the old premises
being at 386 Walworth Road. Emily (far
right) was married to William Arment
and after taking the reins, the shop
was re-named. It moved to its current
location, 7–9 Westmoreland Road in
1979 and the photograph below shows
the shop in 1994 when it celebrated
the occasion of its eightieth birthday.
Arment's is still family run with
grandson Roy and his wife Cheryl now
running the business.

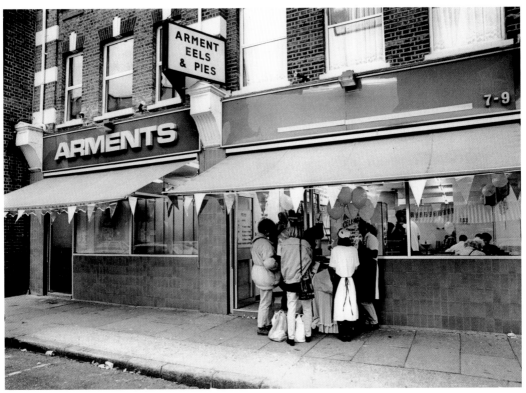

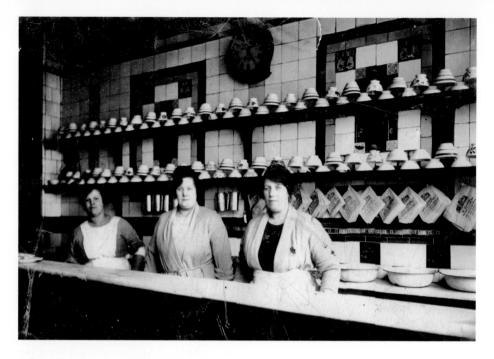

Arment's Eel, Pie & Mash Shop *c.* 1913/2010

The Walworth Road of today has a multitude of take-away, fast food outlets available, but Arment's carries on in its traditional way, remaining true to its origins. The minced beef and pastry pie, with mashed potato and parsley sauce, known as liquer, has been a quality, healthy meal for generations of Londoners. Stewed and jellied eels are also available on the menu. The interior of today's shop mirrors that of the look of the shop back in the early 1900s.

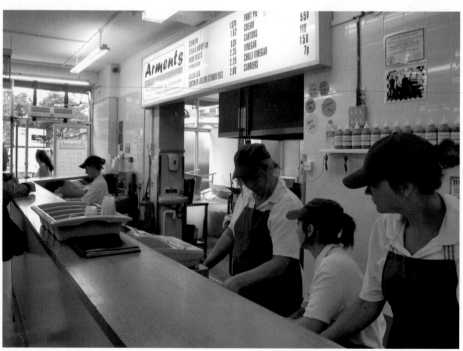

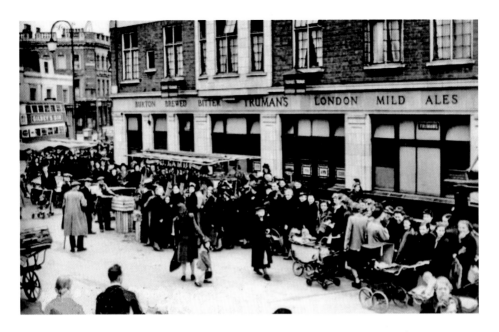

The Red Lion c. 1950

Situated at 407 Walworth Road on the corner of Westmoreland Road, this pub is home today to a mainly local Irish clientele. A Red Lion pub has stood here for over 200 years, with Red Lion Row nearby and Red Lion Mews once on the local map. The photograph above shows the queue for food rations in Westmoreland Road and clearly shows the exterior of the pub, which has changed little over the years. Hollywood film legend Clint Eastwood was recently in The Red Lion whilst filming locally on his latest production *Hereafter* which stars Matt Damon. In the last year a pair of beautifully painted refuse bins, showing the exterior and interior of the pub has been parked on the corner outside. They are the work of artist Morganic and were commissioned by Southwark Council as part of their 'Cleaner, Greener, Safer' project.

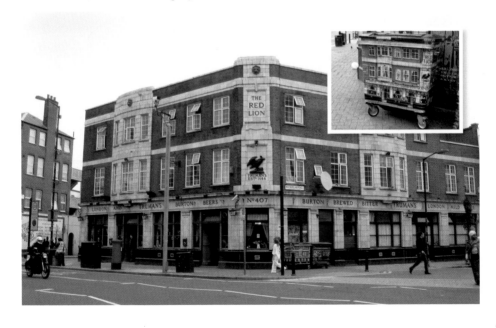

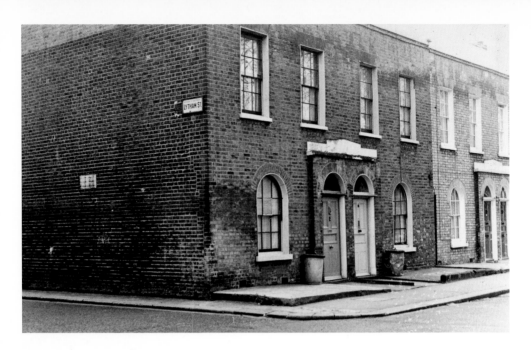

Lytham Street *c.* 1978

This fine Georgian house in the quiet back street of Liverpool Grove on the corner of Lytham Street has a stone plaque embedded in its side wall, which reads "One Foot East Of This Wall Is The Property Of Mr. Thomas Peacock". The houses on Liverpool Grove are facing the south side of St Peter's Church. Many have been restored to their former glory and are now very desirable residences in the area.

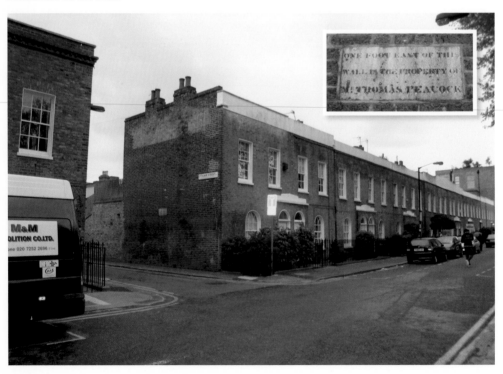

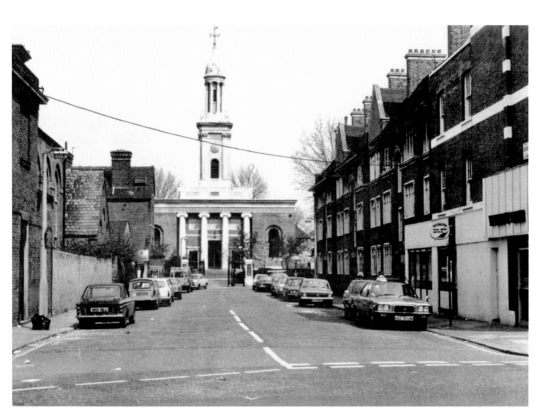

St Peter's Church c. 1978

Situated at the bottom of Liverpool Grove, building work began on the church in 1823; the architect being Sir John Soane, designer of the Bank of England. It has been central to many local people's lives ever since. The churchyard is today a delightful garden named 'Monkey Park' after the small zoo created for the amusement of local children by Canon Horsley at the end of the 1800s. Horsley also cleared the crypt of coffins and had them re-interred at Woking Cemetery. He then used the space created to serve free meals to the children who attended the St Peter's school, which was associated with the church and built in 1835, and later replaced by the present school in 1905. The housing block to the right of the photograph above was built for the Ecclesiastical Commissioners of England (ECE) in 1842 and renovated in 1927.

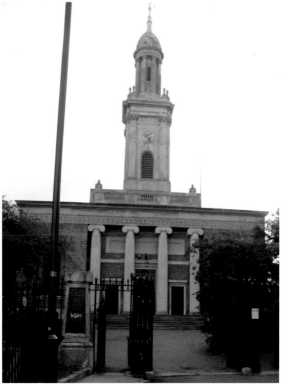

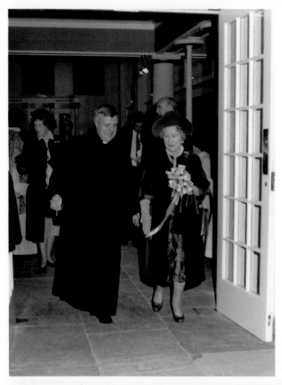

St Peter's Church *c.* 1982
The crypt was also used as a shelter from the Zeppelins of the First World War and was used again during the Blitz of the Second World War. Sadly, two bombs scored direct hits on the church in 1940, killing at least sixty-five of those sleeping below, with many, many more injured. Thankfully, the crypt was so well built that the building survived. The church was redecorated in 1982 using Soane's original colours. The church was also re-dedicated and Her Majesty the Queen Mother was in attendance for the service and can be seen in the photograph (left) with Father Paul. The crypt today is known as 'Inspire' and is home to a café and meeting rooms and provides space for many activities such as dance, drama and music.

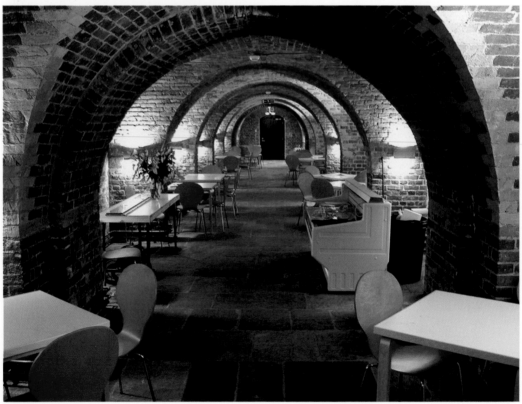

Faraday Gardens c. 1969

This local swing park is named after scientist Michael Faraday (1791–1867) who was born in nearby Newington Butts. Faraday produced groundbreaking work in the fields of electricity and magnetism, leading to the successful development of electro-mechanical machinery, which came to dominate heavy industry in the nineteenth century. On a lighter note, his face was used on the twenty pound note from 1991 to 2001. The Gardens were built on land given as a gift by the Church Commissioners in 1905. An air raid shelter was built here during the Second World War and could house up to 600 people. The Broadmayne and Woodsford housing blocks that can be seen in the background of both photographs were erected in 1965. More recently the Gardens have been used annually for the Walworth Festival which brings local voluntary and community groups together for a fun day out.

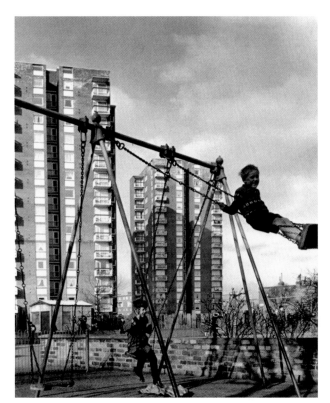

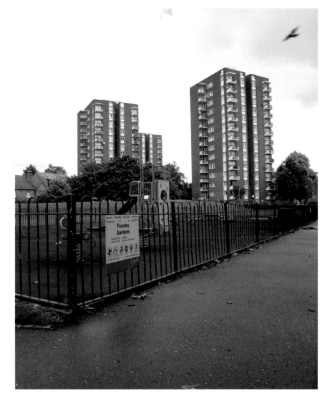

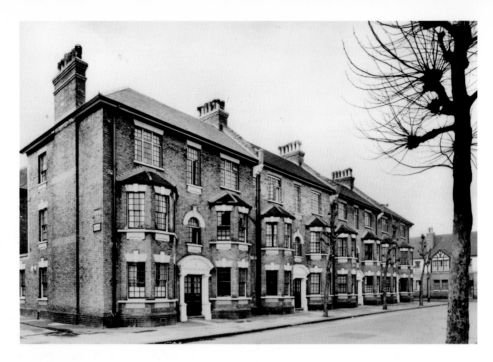

Villa Street _c._ 1950

This street is part of the Octavia Hill Conservation Area. It is roughly 22 acres in size, and since 2006 has been owned and run by Grainger GenInvest. It was developed from slum housing in the early 1900s in conjunction with Hill, a social reformer and pioneer for affordable housing, with a special interest in city inhabitants, who later co-founded The National Trust. One former famous resident was long time Benny Hill sidekick, Jackie Mann. This conservation area provides 600 dwellings and there is a health centre at 47 Villa Street.

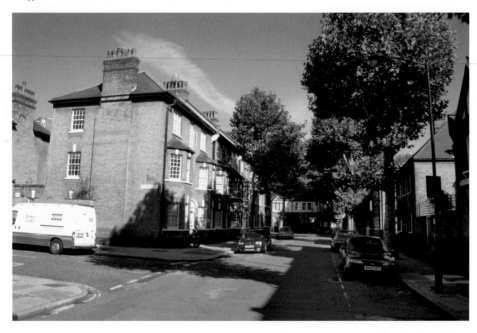

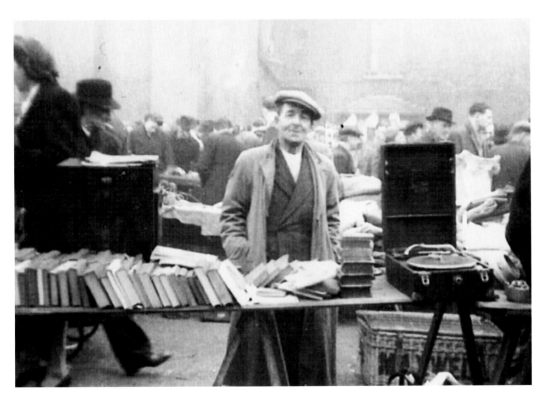

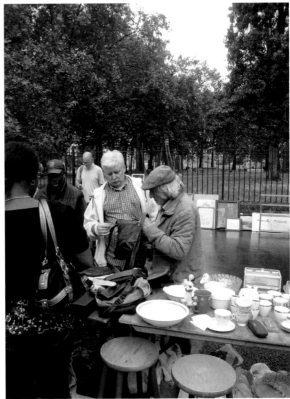

East Street Market *c.* 1948
Known locally as 'The Lane', this market has been at the heart of the area since it officially started trading in 1880. However, there are reports of street selling in Walworth going back to the sixteenth century and stalls lined the Walworth Road right up until the late 1800s. Gradually the traders were eased into East Street when tramlines were laid in 1871. In the early days of the market, no pitch was guaranteed and traders had to wait in the side streets for a policeman to blow his whistle at 8.30 am before they could rush out and construct their stalls. Regular pitches began in 1927. The vast majority of the traders were local people who lived in the back streets that surrounded the market. And their customers came from the same streets too as few people could afford to travel too far from home.

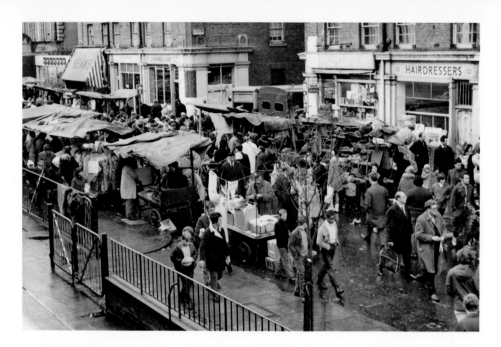

East Street Market *c.* 1960

As others head for church on a Sunday morning, many more still head for 'The Lane'. The market is now open six days a week, closing only on a Monday, and perhaps the market isn't as busy as it once was, but fruit and veg, cut flowers, clothing, household goods and food from around the world can still be bought here. It has been estimated that in 2010 Walworth has a local population from over 50 different countries and the market now reflects that diversity. It's fair to say it has seen better days, but despite competition from multi-national supermarkets and poundshops it continues with over 250 stalls on Saturdays and Sundays.

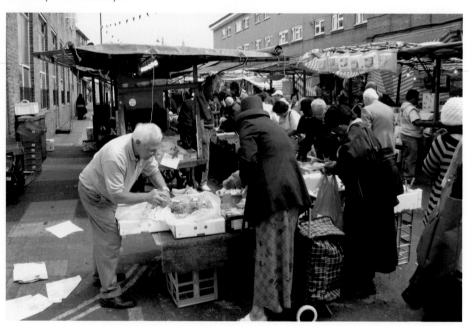

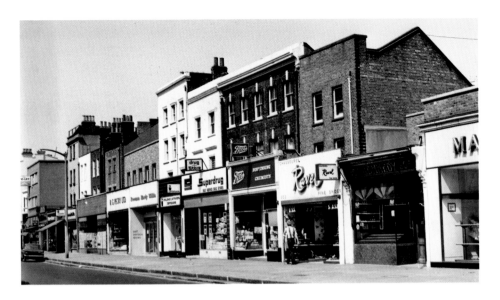

Shops on the Walworth Road 1978

The Walworth Road has always been a busy shopping area, whether it was goods being sold from market stalls as in the early nineteenth century or, as for the past 100 years or so, from established shops. And nothing highlights the passing of the years more clearly than the coming and goings of businesses on a high street. The Marks & Spencer double fronted shop is a staple of the road having first opened in 1914. Kennedy's closed in 2007 and the Grade II listed building currently has temporary tenants. Boots and Superdrug, whilst still trading on the road, have each moved premises since 1978 with Boots moving a few shops to the left, with Footlocker now in its original position, and Superdrug moving into a much larger unit further right. Ravel is now Holland & Barrett, a relative newcomer to SE17, whilst Dolland & Aitchison remains unmoved. Further to the left, the sign for the A1 Stores can just be seen. This family-run firm sold records and tapes as well as fancy goods and greeting cards, closing in 2008.

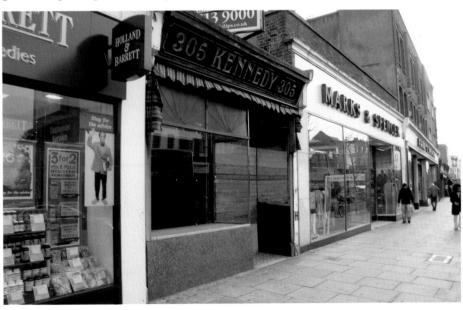

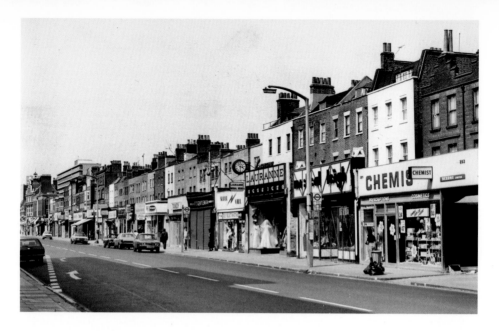

Shops on the Walworth Road 1978

Again, on the east side of the road in the buildings behind and above the shops have in many cases rarely changed over the years with many ranging from 1875 to 1906 and are either storerooms for the retail units below, small workrooms and businesses; or they are residential flats. Comparing the photographs above and below it can be seen a number of shops have changed hands over time, but a few older businesses remain with new shop fronts as in the case of Ridgeways the chemist; one or two others have moved to a new location on the road. On the extreme right is an alleyway from which, since 1948, the Edwards family has run a cut flower stall. The Michael Leigh clothes shop is now further right, back past East Street. Back left, the wooden shutters and the three golden pawn balls of F. T. Gentleman, pawnbroker and jeweller, can be clearly seen, as can the distinctive 1970s Wimpy sign for the burger chain of shops.

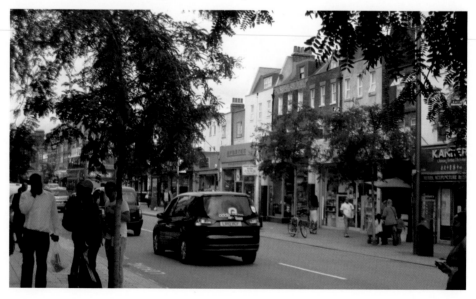

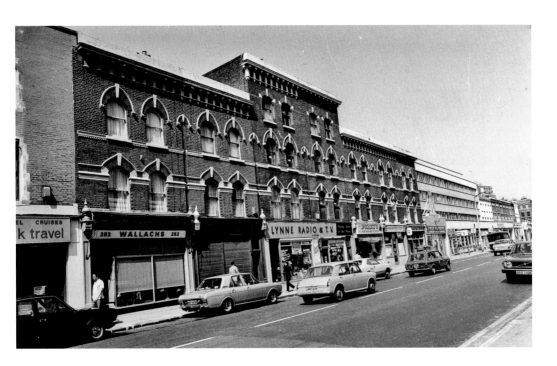

Shops on the Walworth Road 1978

Over on the west side of the road, going north towards the Elephant and Castle, you'll find two family-run firms that have been long established in Walworth. Schwar & Co. have been established since 1838 and Lynne's Electrical Super Store has supplied local families for many years. Further right, Marie's Café is now a Subway food outlet but the Post Office remains and is as busy as it ever has been as other local ones have been closed.

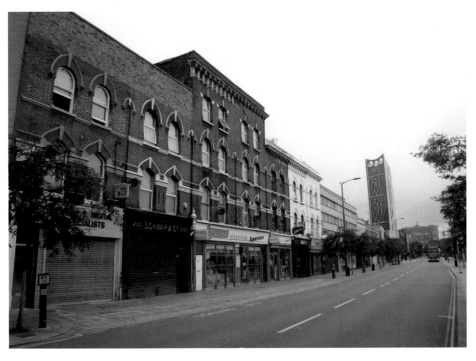

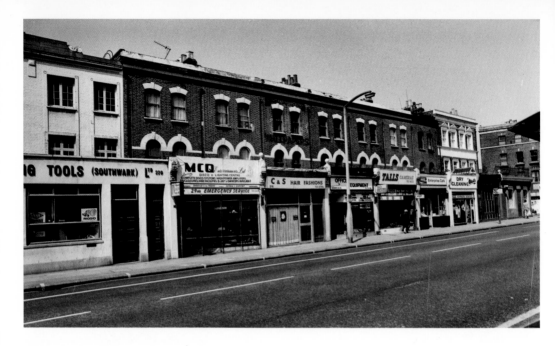

Shops on the Walworth Road 1978

Walworth Road was lined with elegant manors in the early nineteenth century and on its west side, early Victorian buildings can be clearly seen behind and above this row of shops. MCQ, at 218 are suppliers of audio and hi-fi equipment, established in the early 1970s; C&S Hair Fashions is now known as Hair Hunters; Talls Cameras at 212 is now home to the Arif Bakery and Pâtisserie; Café Time is still The Enterprise Café with a new name; and Omar Dry Cleaners is in the same shop as in 1978. At the very right of both photographs is the fine white-painted front of the one time Kings Head pub, now trading as William Hill bookmakers.

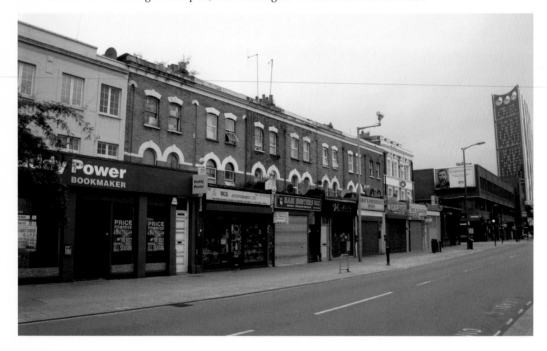

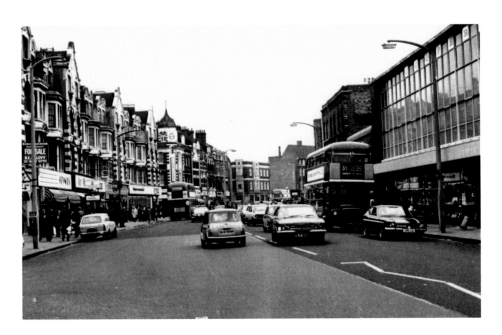

Shops on the Walworth Road 1978

Looking back towards Camberwell, the highly ornate buildings from 1908 are the stand out feature of this photograph. Thankfully they have survived and many are now private dwellings. To the right of the photograph above is the Co-operative store which is now a Fitness First gym upstairs and a combination of Peacocks, the Oli Food Centre and an Iceland on the lower level. To the left is Guvnors, a popular gentleman's fashion shop, and Art Wallpapers. Bet Fred the bookmakers, Argos and Superdrug are the large stores in this parade of shops today. The clock which is on top of the old Harvey & Thompson jewellers and pawnbrokers can still be seen with the shop now Panache Exclusive Footwear, with Harvey & Thompson having moved to a smaller unit still on the Walworth Road.

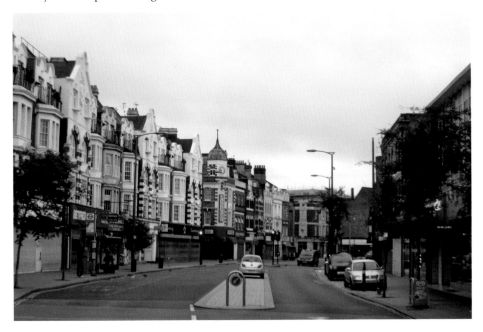

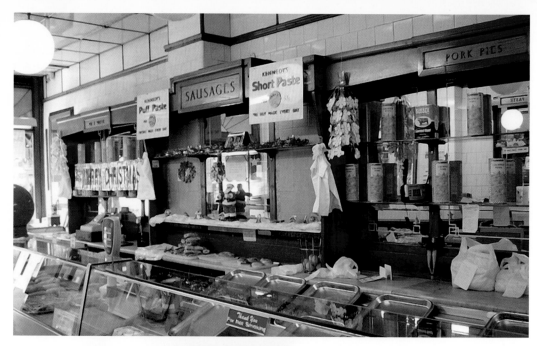

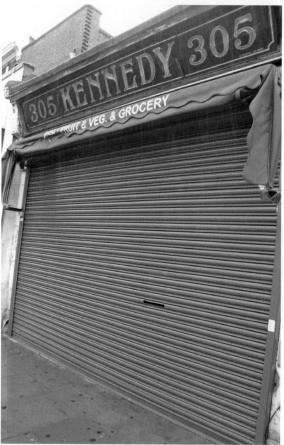

Kennedy's *c.* 1990

The Kennedy's company began trading in nearby Peckham in 1870, and they originally sold cooked ham, fish, and other meat products. Eventually they had a small chain of shops in the South London suburbs. This shop at 305 Walworth Road opened *c.* 1923 and was a firm favourite with the locals. The original design of both the interior and exterior has changed very little over the years. It has a timber shop front, Art Deco style stained glass, and a polished glass shop sign. The shopfitters were W. Piggott & Co. based in Clerkenwell. Due to the amount of original features, the shop has been classed as Grade II listed by English Heritage. The Kennedy family ceased trading in late 2007, resulting in all of the branches closing within months of each other, this despite a vigorous local campaign to keep them open.

Temple Bar *c. 1955*

Situated at 284–286, the mock Tudor frontage is a familiar site on the Walworth Road. In 1949 the pub was used as an art gallery by the artist and occult magician Austin Osman Spare, who had exhibited at the Royal Academy in 1904 at the tender age of seventeen. For a month, Spare's idiosyncratic paintings and drawings hung in the pub. The views of the pub locals on the surrealist pop art style artwork sadly aren't recorded.

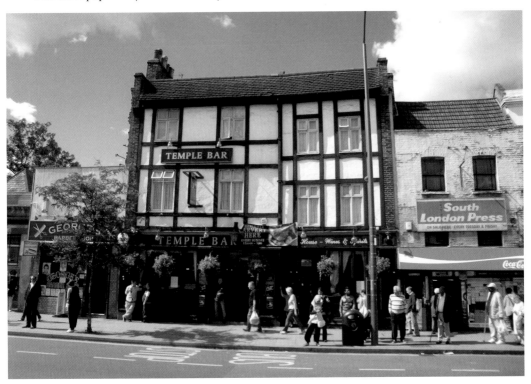

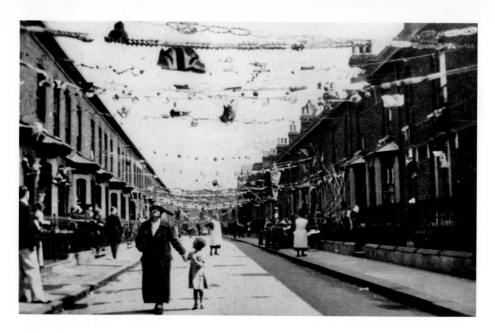

Street Bunting 1937 and 2010

A child walking with her grandmother in Nursery Row takes a look at the houses bedecked with union jack flags and bunting on the occasion of the coronation of King George VI in 1937. So named due to the proliferation of plant nurseries once established here, one side of the Row was owned by the Rolls Estate and the other by the Yates Estate. Edward Yates, the founder, built large areas of housing in Walworth in the late 1880s. The family run company still have an office at 205 Walworth Road. The flags were put out again on the streets of Walworth in celebration of England taking part in the 2010 football World Cup played in South Africa.

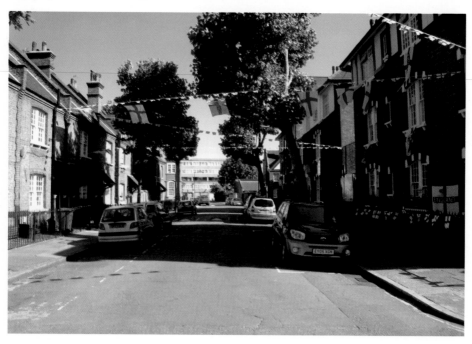

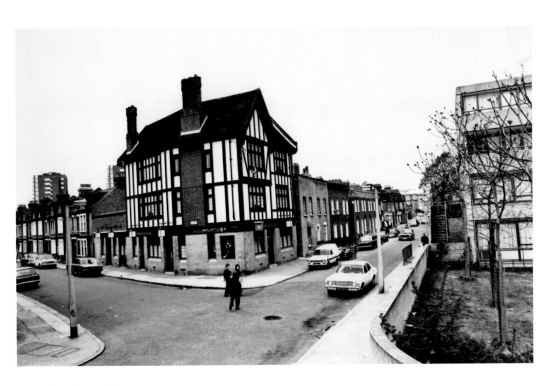

The Queen Anne *c.* 1977
A fine example of a mock Tudor style public house, the 'Annie', was situated at 126 Dawes Street on the fringes of the Aylesbury Estate. However, it has been converted to flats in the last few years and is now called Old Queen Anne House. In 2008 over 1,900 pubs in the UK closed for good, and this trend is continuing at an alarming rate.

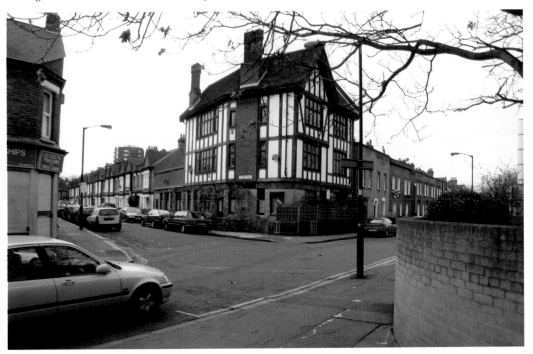

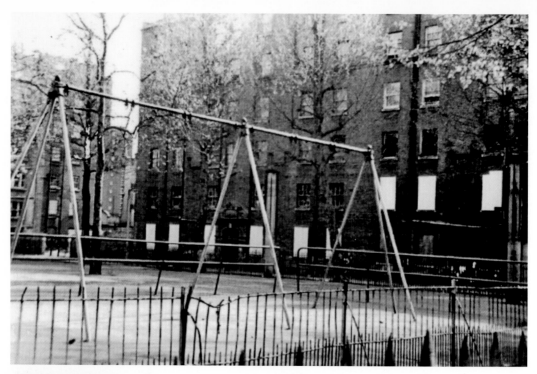

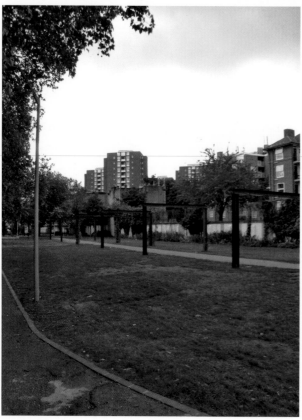

Blendon Row c. 1965
These tenement block style
buildings, situated very close
to East Street, gained national
notoriety when they were
featured in the celebrated and
award winning 1971 Thames
Television documentary *We Was
All One* made by the film maker
Ken Ashton. The film focused
on the way of life lived by those
in and around the Elephant and
Castle and Bermondsey. The
residential blocks were shown to
be in a very poor state of repair
and overrun with rats. Southwark
Council had begun a programme
of slum clearance in Walworth
as far back as the 1930s, but
these blocks were still inhabited
for many years after that, with
at least three families sharing
one toilet. They were eventually
demolished in the late 1970s. The
area on which they once stood is
now a park.

Nursery Row *c.* 1962

These tightly packed rows of late
Victorian houses with ground floor bay
windows, are still fondly remembered
by those who lived in them, despite
their lack of amenities. They are
described as having no heating,
no bathroom and no running hot
water and with an outside toilet. The
properties were compulsory purchased
and demolished with many of the
residents moved onto the newly built
Aylesbury Estate. The area is now
grassed over and forms a small park.

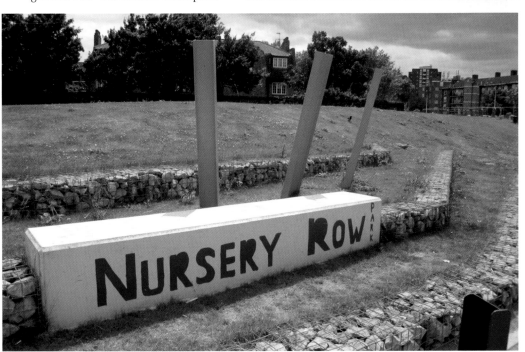

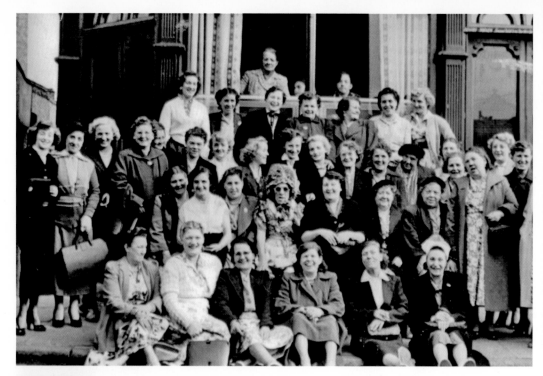

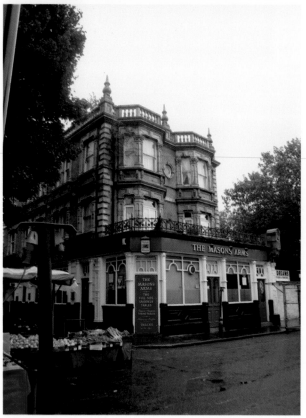

The Masons Arms *c.* 1955

A group of female customers gather outside the pub, all dressed in their finery getting ready to leave on a 'Beano' (day trip) to Hastings. The Masons Arms at 109 East Street is a large, imposing, but none the less ornate building constructed in 1898 and is remembered fondly as a great market pub. High up on the front of the building there are stone-carved examples of the tools used in the mason's trade, namely a compass and a mallet. The Masons Arms achieved a certain notoriety in Walworth's history in the mid 1970s, when it became the first pub in the area to have strippers perform on the premises.

Charles Vickery Drysdale *c.* 1977

Situated at 153a East Street on the corner of Dawes Street is a very tatty looking building today. What singles it out for attention is the English Heritage blue plaque upon its wall. In 1921 Doctor Charles Vickery Drysdale opened his first birth control clinic here. The clinic, and the advice it gave, was seen as an enormous help to the local women of Walworth and surrounding areas, many of whom already had large families and were living in terrible conditions on very low wages. Doctor Drysdale later became a founder of the Family Planning Association in 1930. The building, which later became a Brook Clinic dispensing sexual health advice to the under twenty-fives of the area, currently stands empty.

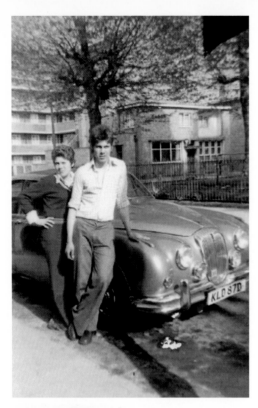

The Prince Regent *c.* 1971
The pub can be clearly seen in the
background of the photograph of the boy and
girl posing proudly in front of the motor car.
The pub building is modern in appearance
compared with others in SE17, and is
believed to have been built in late 1930s. This
one time Truman house is number 3 Deans
Buildings on the corner of Orb Street, close
to East Street. Like many other 'locals', the
building has now been converted to flats.

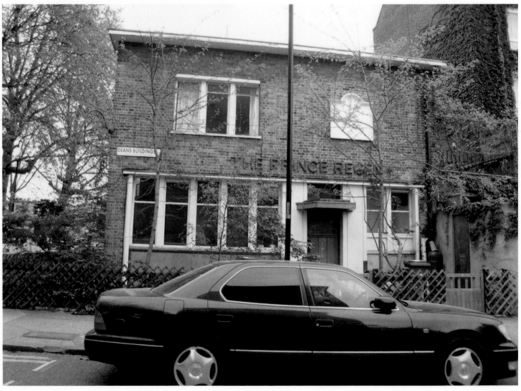

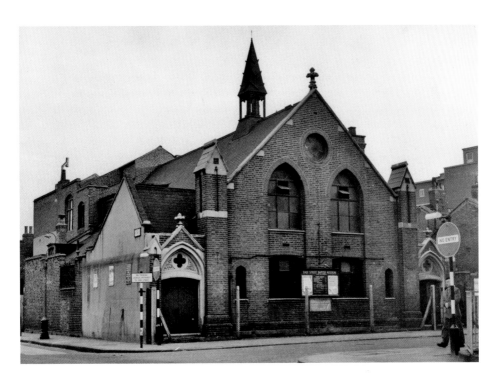

East Street Baptist Church *c.* 1960

At the rear of the building a stone plaque identifies it as once being the Richmond Street Mission and Ragged School opened in 1859. Princess Christian, daughter of Queen Victoria and Prince Albert, laid the foundation stone of the church on this site in 1896. Situated at 177 East Street on the corner of Portland Street, and once known as the East Street Mission, the church is still in use averaging a congregation of fifty people on most Sundays.

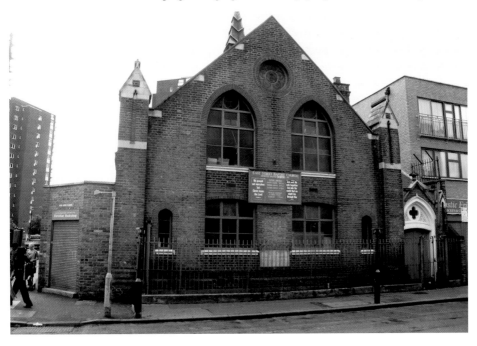

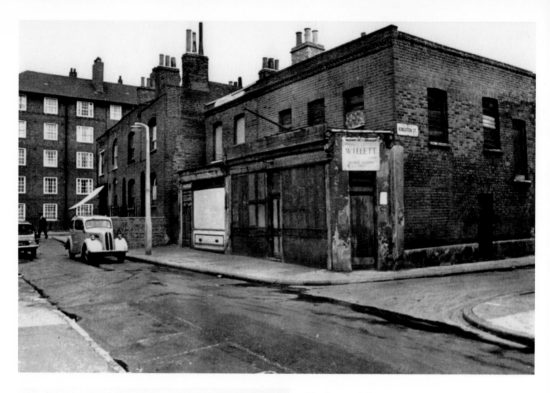

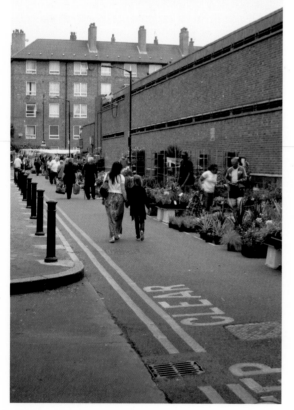

Blackwood Street c. 1957
This quiet nondescript little back street
is effectively asleep for six days of
each week, but on a Sunday morning
it comes alive when the flower market
opens for business at 7am. The traders
sell a vast variety of garden plants. The
older Walworth generation often refer
to this as the root market. In the 1950s
it was also home to street entertainers,
with a local escapologist being a
particular favourite and caged birds
were sold here up until the late 1960s,
a description captured in the song
Barrers in the Walworth Road:

'Canaries there all posh
What is sparrers
When they are washed
Orn the barrers in the Walworth Road'.

The buildings in Blackwood Street
seen in 1957 have all gone but the
council estate block Nicholson House
looms large in both photographs.

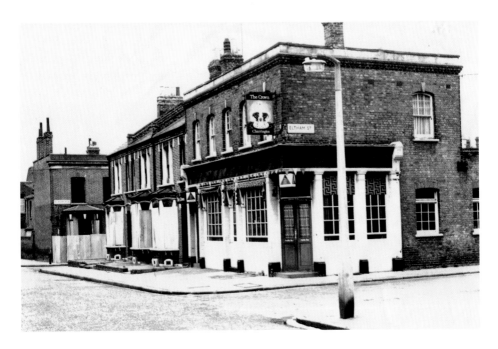

Brandon Street *c.* **1978**

The Crown pub is still standing whilst all around it has changed dramatically in this turning off of Browning Street. The original glazed earthenware 'faience' tiling on the pub has made it very popular with film and TV crews. It appeared in an episode of the BBC drama *Ashes to Ashes*. A child (inset) is seen sitting on the steps of a house now demolished and the land around the pub now forms part of the Nursery Row park.

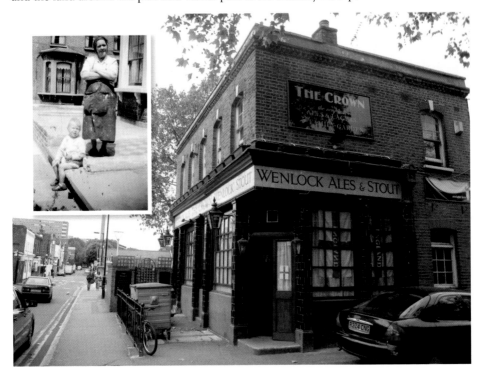

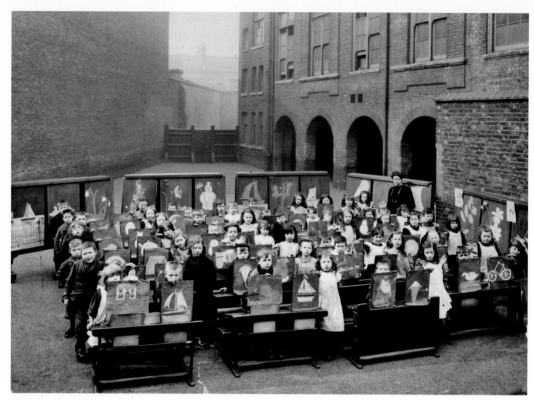

**Flint Street School/English Martyrs
RC Primary School *c.* 1910**
In this charming photograph a group
of school children proudly show off
their artwork to the camera. Formerly
the Flint Street School Board School
built in 1875 by E. R. Robson, this
Grade II listed building is now the
English Martyrs Roman Catholic
Primary School. A rear extension was
added in 1904. Made in red brick it
has some particularly fine terracotta
detailing, with a plaque depicting
'Truth' showing a book of learning to
two children. Panels of cut brickwork
are decorated with flowers and fruit.
The building has been described as
'surprisingly bold and decorative for
a board school of this date'. Today,
this welcoming school community
includes a nursery.

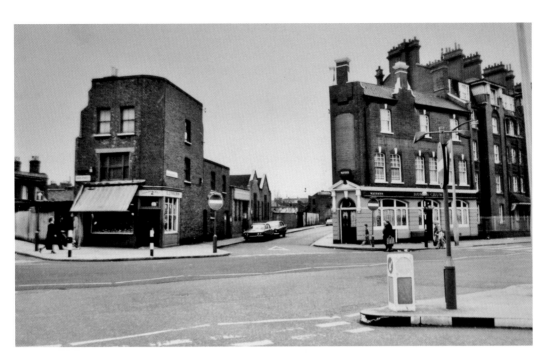

Rodney Road c. 1978

Said to be named after a son of the local property developer Edward Yates, Rodney Road runs parallel to the east of the Walworth Road. This stretch of it has a few interesting buildings. The Rose and Crown is very much a locals' pub situated as it is away in the back streets and which stands directly next to a group of Peabody Trust buildings. George Peabody was a wealthy American philanthropist who started his housing trust in 1862 to provide good quality accommodation for the poor of London. The Peabody Group, as of 2010, owns and manages 19,000 homes in the capital.

To the left of the pub, the butcher's shop has since been demolished but the twin-peaked roof of the English Martyrs Parish Hall and Social Club is still standing. This is in Wadding Street, named after the wadding factory that once operated here.

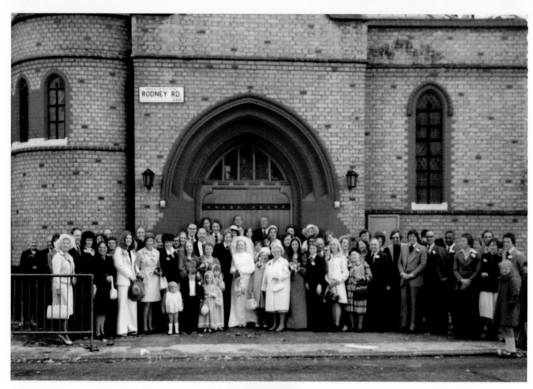

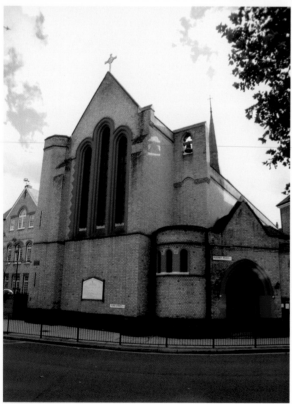

English Martyrs Roman Catholic Church 1974

A 1970s wedding party pose outside the church at number 142 Rodney Road. With the large influx of Irish and Italian Catholics into Walworth in the mid 1800s, the need for a Catholic Church to be built in the area was pressing. Money was raised by donations from all over the world. The name of the church is a dedication to those who died for their faith at the time of the Protestant reformation in the sixteenth century. It was built in 1902 and consecrated in 1919. Carmelite Friars, who first arrived in Britain in 1242, minister the church.

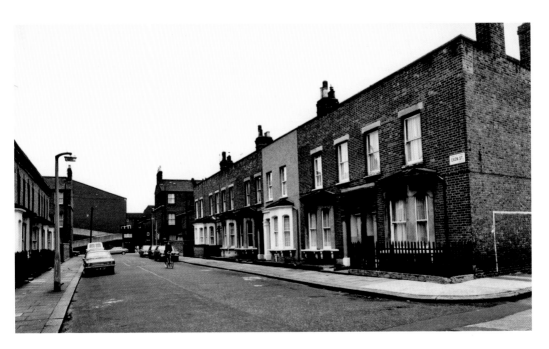

Exon Street *c.* 1977
Many of the houses in this quiet backwater near to the Old Kent Road have been saved and restored in recent years. The authors were particularly pleased to find the goal posts from the 1970s still there and ready for use.

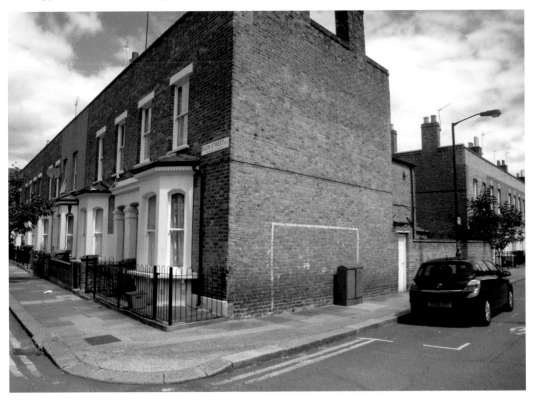

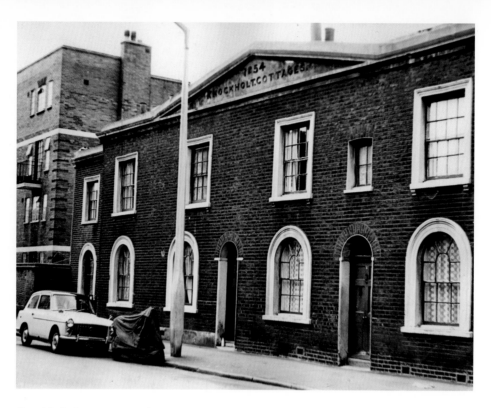

Knockholt Cottages *c.* 1963
Elsted Street, to the east of the Walworth Road, is the location for these cottages built in 1854, when most of the surrounding area would have been fields. Sometime in the last forty years they have lost the stone-carved pediment which proclaimed their name and the year they were built. A door and a window have also been lost and filled in with bricks and the original sash windows have been replaced.

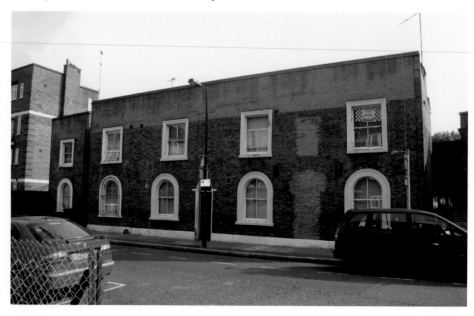

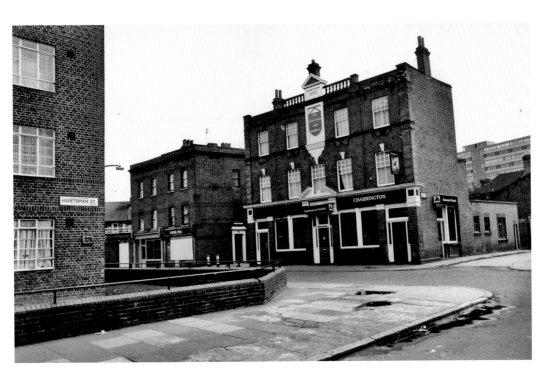

The Huntsman and Hounds *c.* 1975
Found on a quiet turning near to the East Street market, this fine looking pub has stood here at number 70 Elsted Street, on the corner of Tisdall Place since 1892. Many costermongers had their wedding receptions here in the 1920s and 1930s.

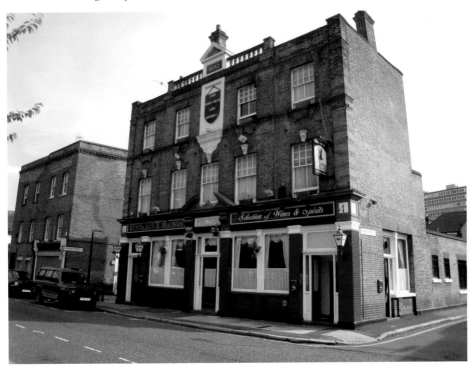

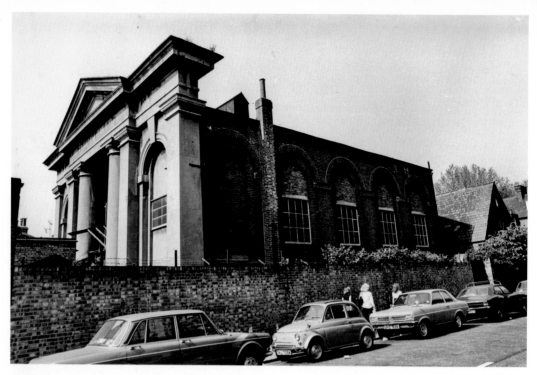

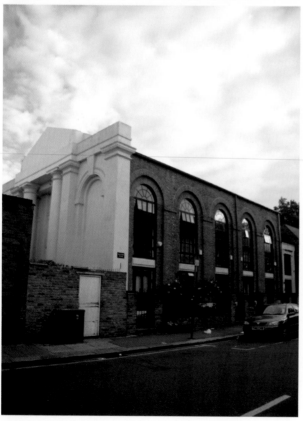

Sutherland Chapel *c.* 1978
Built in 1842 between St
Peter's Church in Liverpool
Grove and the Walworth Road,
this Congregational Chapel
was intended for Dr Edward
Andrews, the minister at the
nearby Beresford Street Chapel
(Beresford Street was re-named
John Ruskin Street in 1937).
However, Andrews died before
the chapel was completed and the
Reverend John Wood became its
first minister. Sutherland Chapel
closed in 1904 and became the
Electric Theatre Company, the
first 'picture palace' in Walworth,
which seated on the original
pews 780 paying customers. Later
it became a storage space for a
theatrical company and was then
developed for luxury housing
and is today known as Malvern
House. The original façade of the
Chapel can still be seen directly
behind the shop 'Art and Magic'
at 343–345 Walworth Road.

Herbert Morrison House c. 1950
This building at 195 Walworth
Road has a full and varied
background. Found on the
corner of Browning Street,
from 1895 it opened as The
Robert Browning Settlement, a
place where medical and legal
advice was made available,
alongside social and educational
activities, to the poor of SE17.
Associated with the Browning
Hall situated further down on
York Street (re-named Browning
Street in 1937 in honour of one
of England's greatest poets;
Browning being baptised there
in 1812). The Settlement itself
was established by Herbert
Stead, Congregationalist minister
and social campaigner, who
later became a key figure in
establishing the state funded
old aged pension in 1908. A
stone plaque on the side of the
building declares that Charles
Booth, himself an important
player in documenting the plight
of the poor in London, officially
opened it in June 1902. A carved
sign above its white door reads
'All's Love, All's Law'. From 1899,
it became home to the National
Committee of Organised Labour,
later the headquarters of the
London Labour Party. Herbert
Morrison (1888–1965) was born in
nearby Lambeth and who, despite
little formal education, rose to
become deputy Prime Minister
in Clement Atlee's government of
1945. He was also an ex-president
of The Browning Settlement, later
named Herbert Morrison House
in his honour. He became Baron
Morrison of Lambeth in 1965.
His grandson, Peter Mandelson,
became a cabinet minister for
both Tony Blair and Gordon
Brown. The building is now home
to solicitors Kaim Todner.

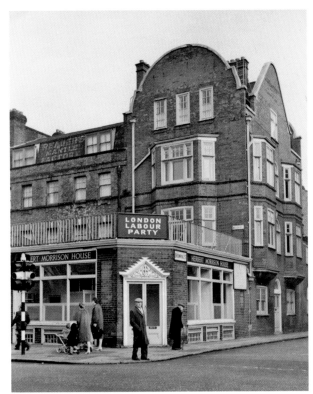

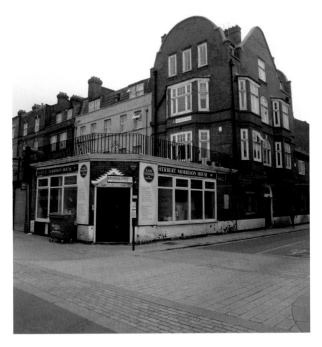

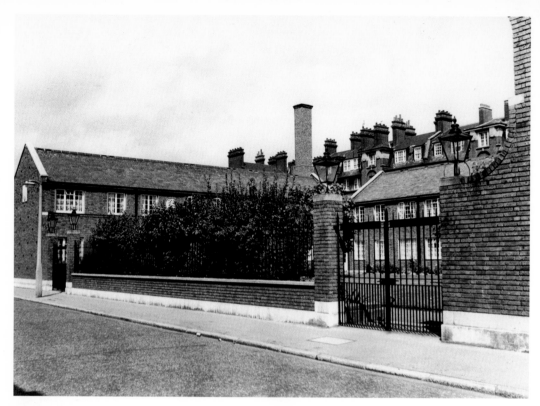

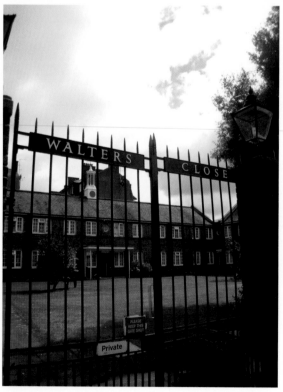

Walters Close *c.* 1977
John Walters, a clerk to the Drapers'
Company in 1616 to 1656, founded
almshouses in Southwark in the 1650s
and Walters Close was founded as a
part of that project. Over the years it
has moved to various locations in the
borough, finally settling in Brandon
Street in 1961. The Drapers' Company
founded 600 years ago in London and
originally involved in the woollen
trade, is today mainly a charitable
institution, it still plays an important
part in the functions and government
of the City of London. Walters Close,
with its clock tower and courtyards,
is divided into forty-three sheltered
housing flats, comprising a mixture
of bedsits and one and two bedroom
accommodation all in beautifully
maintained surroundings.

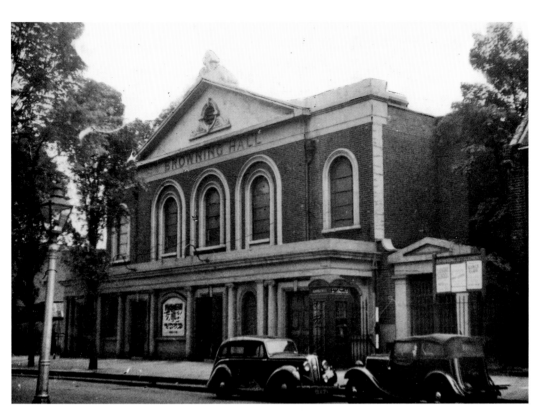

Browning Hall c. 1957

Formerly an independent church built in 1790, it was originally known as the York Street Congregational Chapel. Robert Browning, one of England's greatest poets, was baptised here in 1812 and the chapel was later re-named after him, as was the street in 1937. During the latter years of the eighteenth century social work initiated at the chapel did much to ease the suffering of the poor and destitute of Walworth. The Browning Hall was demolished in 1978 after succumbing to fire damage and the Ben Ezra Court housing estate now stands on the site. The telephone box which can be seen in the 1957 photograph is still *in situ*, and all that remains of the Browning Hall is a tomb dedicated to Richard Holbert and Captain James Wilson, which can be found on the edge of the housing estate.

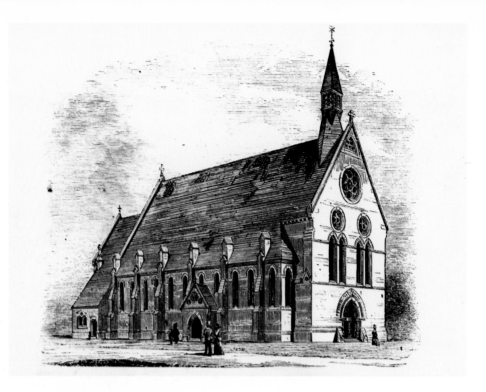

St Mark's Church Hall *c.* 1880s

This lovely little building was the parish hall of St Mark's Church, once of East Street, which was designed by Henry Jarvis in 1874. Enemy bombing in the Second World War destroyed the church. The hall once had a viewing balcony and its original stone font can be found at the rear of the building. The building has been the Chapel Furnishers store for the past twenty-four years.

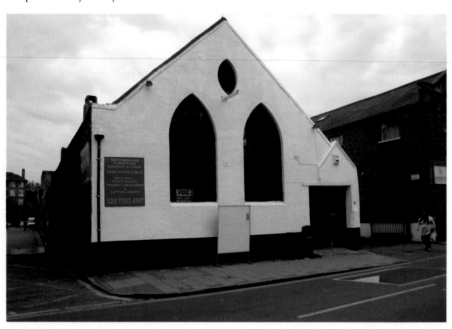

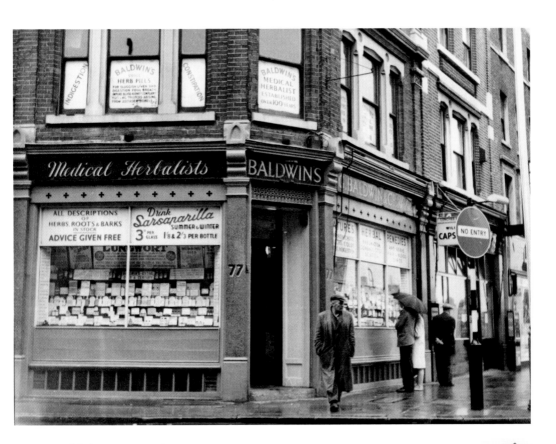

G. Baldwin & Co. *c.* 1960

G. Baldwin & Co. is London's oldest and most established herbalist. The company was founded by George Baldwin in 1844 and the photograph above shows the original shop, which was at 77 Walworth Road. In 1918 Henry Dagnell joined the company. His role was to restore the failing G. Baldwin business, which he did, leading him to eventually buy the company. In 1969, Baldwin's was forced by development work on the vast Heygate Estate to relocate to 173 Walworth Road where they are still based today. In 1978, they bought number 171 next door, and combined both buildings.

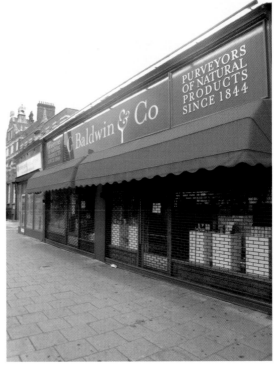

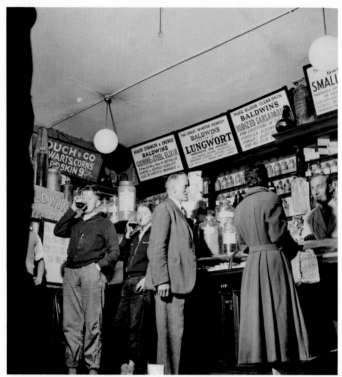

G. Baldwin & Co. *c.* 1960
Stephen Dagnell joined
the company in 1981 and
it continued to thrive as
the interest in natural
and alternative health
remedies began to boom.
His father retired in 1989
and Stephen runs the
company today, the third
generation of Dagnell to do
so. Baldwin's is recognised
as the leading supplier of
essential oils and other
natural products in the UK
and it has a thriving mail
order business as well as
a solid core of customers
who continue to visit the
shop. Famous customers
include actor Terence
Stamp, introduced to the
shop by Michael Caine.

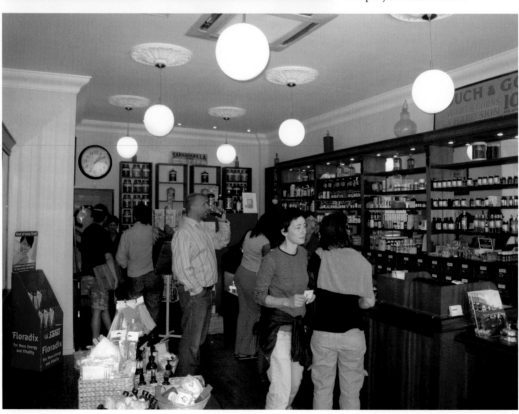

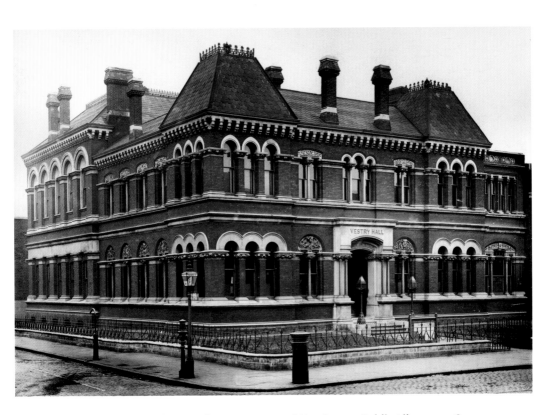

Vestry Hall incorporating Cuming Museum and Newington Public Library *c.* 1899

This important group of buildings are all Grade II listed. At 157 Walworth Road, The Vestry Hall of St Mary Newington, to give it its full title, was built in 1864 and was the seat of municipal authority, later to become the Town Hall for the Borough of Southwark between 1900 to 1965. It also later housed a registry office. The Vestry was designed by Henry Jarvis, district surveyor at the time, and built in red brick with white and black stone trim. An extension was added in 1900.

The design is described as 'French Second Empire and High Victorian Gothic'. The Newington Public Library was constructed between 1892 and 1893 by builder J. Grover and Sons, from drawings by architect E. B. I'Anson in a Dutch Renaissance style. The Cuming Museum, a gift to the borough by Henry Syer Cuming in memory of his father Richard, was built between 1902 to 1906. Acknowledged as one of London's finest local museums, it began with Richard Cuming collecting objects from the age of five. Coming as he did from a well-to-do family, Richard could devote his time and family money to his ever-growing collection. His son Henry carried on his father's work after his death in 1870. Henry died in 1902 and bequeathed the collection and money to house it to the Borough of Southwark. It was housed in the same building as the Newington Library at 155 Walworth Road originally and it opened in 1906. Now housed at 157 Walworth Road, it continues to display part of the Cuming archive as well as holding temporary exhibitions.

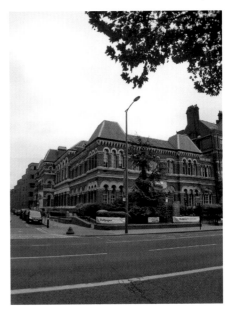

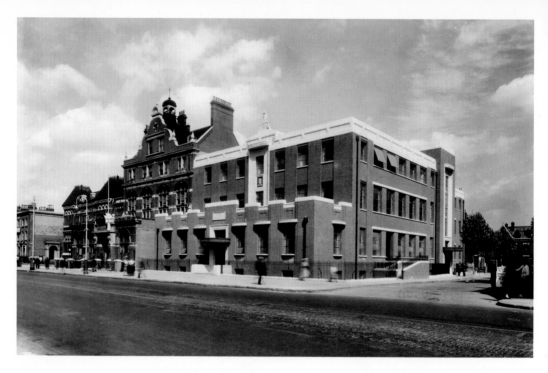

The Walworth Clinic *c.* 1937

Formerly known as the Public Health Centre of Southwark, the clinic stands on the corner of the Walworth Road and Larcom Street. Grade II listed it was designed for the Borough of Southwark by Percy Smart and built between 1936-37. It's a modern, almost deco-style design in red brick,

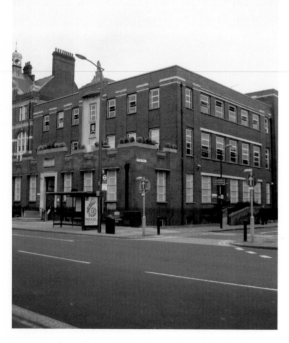

with stone adornments and a flat asphalt roof. A plaque above the door declares 'The health of the people is the highest law'. A group of statues sit on top of the building and show a woman holding a rod of Aesculapis, a symbol of healing and medicine, with two children at her feet, one holding a doll. This pioneering health centre was well established in advance of the National Health Service Act of 1946. It comprised a solarium, TB clinic, X-ray department, a dentist clinic and a maternity and child welfare centre. Laboratories and health education department offices were also on site. Still in use today, the clinic specialises in family planning and offers sexual health advice. Southwark Council blue plaques dedicated to Charles Babbage and Michael Faraday can be seen on the building via Larcom Street. Babbage, acknowledged as the father of modern day computing, is believed to have been born at 44 Crosby Row, now Larcom Street in 1791.

War Memorial c. 1973

Situated in a small well-tended garden at the front of the old Vestry Hall building is a memorial to those who lost their lives due to enemy attacks during the Second World War. The main plaque states that 925 people died in Southwark between 1939 and 1945 and two smaller plaques on either side document the losses in nearby Bermondsey and Camberwell. With Walworth being on the direct path to central London, the area suffered extensive bomb damage. The MP for Southwark and Bermondsey, Mr. Simon Hughes, is seen below laying a wreath at the Remembrance Day service in November 2009.

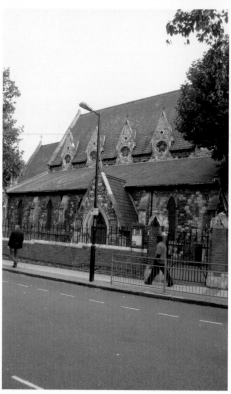

St John the Evangelist Church *c.* 1965
Built in 1860 and designed by Henry Jarvis at
a cost of £5,000, this Grade II listed rag-stone
church has played an important role in the
local community over the years. In 1885 Charlie
Chaplin's parents married here and in the late
1890s its vicar, Arthur Jephson, introduced
'penny weddings' for the poor to encourage
marriage among young couples in the area.
This resulted in forty couples marrying in
the Easter Sunday service of 1901. It was also
known as the 'Coster's Church', the majority
of its worshippers being from market trader
families. In 1912, the 2nd St Johns Walworth
Boy Scout troop set off to a camp in Leysdown
in Kent. *En route* along the River Thames the
boat carrying them capsized, drowning eight of
the scouts. The deaths became national news.
100,000 people passed through the church on
the eve of the funerals to pay their respects
and an estimated crowd of a million watched
the funeral procession from St Johns to the
cemetery in Nunhead, a few miles away, the
following day. The St John's primary school in
Larcom Street opened in 1866.

77 Walworth Road
c. 1965
The original Baldwin's herbalist shop began trading here in 1844. Forced to move in 1969 by development work on the Heygate Estate, the company relocated to its present address at 173 Walworth Road, later also purchasing 171 in 1978. The area is now Elephant Road Park. In the background of both photographs can be seen the eighteen floors of Albert Barnes House, a block that was erected on the New Kent Road in 1964.

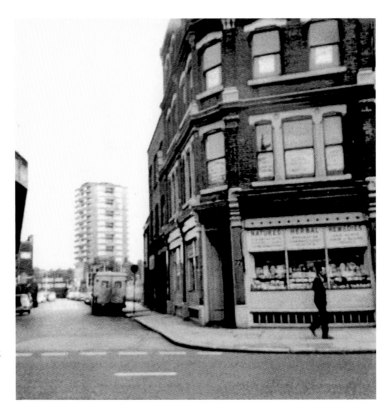

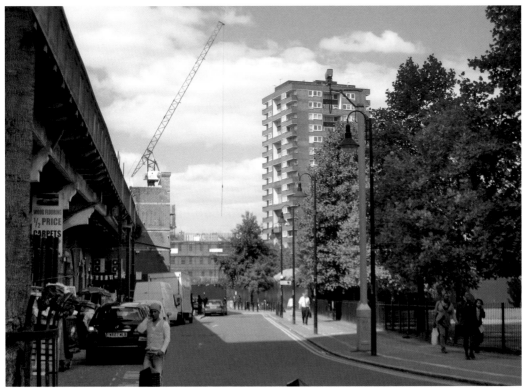

Top End of the Walworth Road *c.* **1967**
Looking down from the Elephant
and Castle, the majority of shops and
flats on the left-hand side of the road
were demolished to make way for
the Heygate Estate development in
the late 1960s. Across the road on the
right-hand side, the majority of these
late nineteenth century buildings
remain intact. The shops there now
are mainly food outlets. At 80–82
stands the popular The Ivory Arch
Indian restaurant. The Electric Picture
Palace cinema, opened in 1910 at 88,
and is now flats. Further left, the
light blue paintwork identifies Julian
Markham House at 114. This provides
accommodation for those studying
at the various local art colleges. The
Dragon Castle Chinese restaurant forms
the lower part of this building.

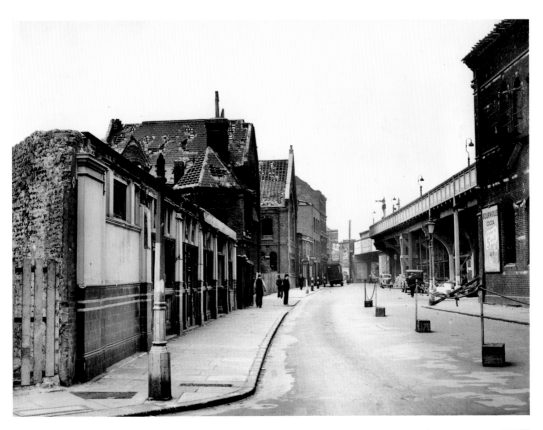

Elephant Road *c.* 1955

Looking towards Walworth Road
directly behind the Elephant and Castle
Shopping Centre, the buildings on
the left have all been demolished and
that area now forms Elephant Road
Park. An entrance to the Elephant and
Castle railway station is situated to
the right. The station, built on a brick
viaduct, opened in 1862. Various small
businesses trade from within the 22
foot high and 25 foot wide railway
arches. Among them is the Corsica
Studios, an independent arts space and
venue; the Re-Cycling second-hand bike
shop; and a couple of South American
cafés. Each year the Carnival de Pueblo,
Europe's biggest Latin American street
carnival begins its journey to nearby
Burgess Park from here.

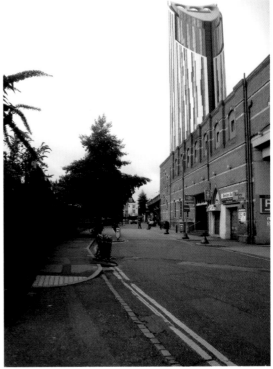

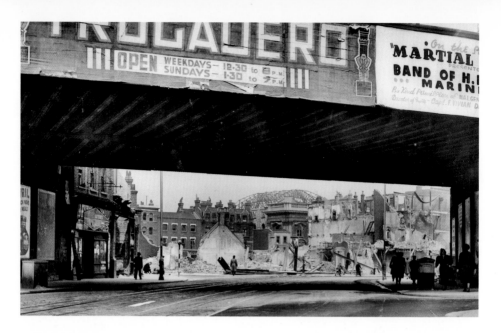

Railway Bridge c. 1940s

The redevelopment work on the Elephant and Castle in the late 1940s can be seen taking shape under the railway bridge, at the top of the Walworth Road. An advert for the nearby Trocadero Cinema can be seen on the side of the bridge. 'The Troc', which seated 3,500 people, closed in October 1963. Seen behind the bridge in 2010 is Strata SE1, the tallest residential building in central London, which stands at forty-three storeys high and which is part of the new regeneration scheme for the area. Designed by the architects BFLS, building work was completed in 2010 and it comprises 408 high quality apartments with space for shops and restaurants below. One of the interesting design details of the new building are the integrated wind turbines which will generate enough energy to meet the demands of thirty, two-bedroom apartments.

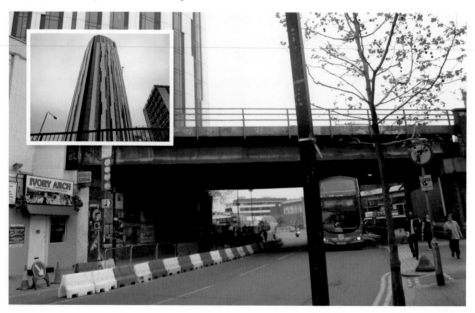

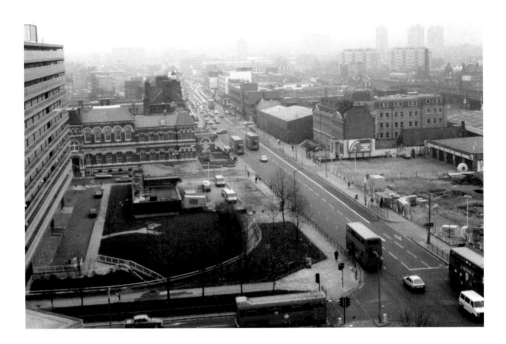

A View from the Heygate Estate *c*. 1987

An aerial view of the Walworth Road seen stretching back towards Camberwell in a photograph taken from the top of the Claydon block on the Heygate Estate. To the left there is a good side view of the old vestry building on the corner of Wansey Street. Far left is the Swanbourne block, also of the Heygate. The single decker bus is travelling down Heygate Street where a Jewish school once stood next door to The Borough Synagogue, which later moved to Wansey Street before it closed in 1960. Across the road to the right, a patch of wasteland stands next door to a Kwik Fit garage, once the site of the Marlborough House Boarding School in the late eighteenth century. A Shell garage operated on the now wasteland until 2007 and this is now used for location parking for vehicles working in the film and TV industry.

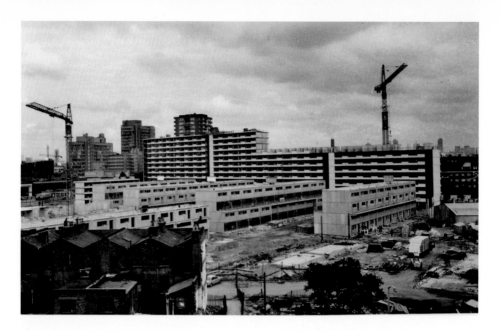

The Heygate Estate c. 1972

Vast swathes of SE17 were demolished to make way for the building of the Heygate Estate, which was completed in 1974. The 'Brutalist' style housing blocks were built and assembled on site from pre-fabricated concrete. A total of 1,194 modern homes were provided, many for those who had moved from the traditional 'two up, two down' terraced housing. However, design faults soon became apparent with crime and vandalism relatively easy to commit on the Estate, but proving difficult to prevent.

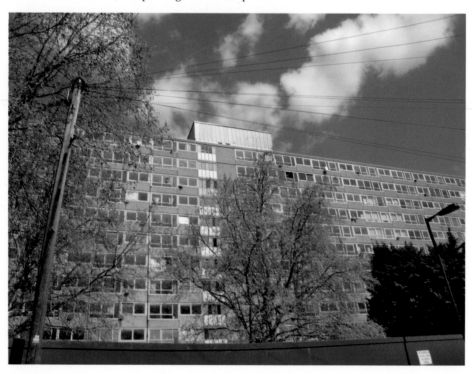

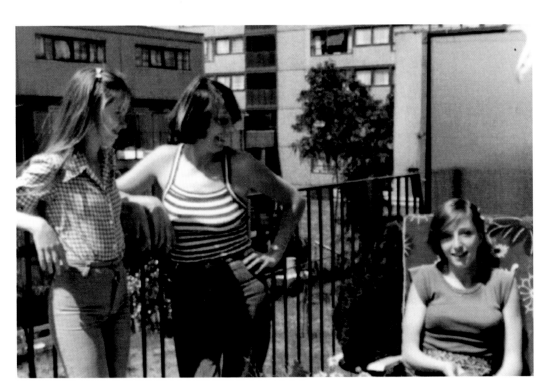

The Heygate Estate *c.* 1976

In 2004 Southwark Council announced a major regeneration programme for the Elephant and Castle, which borders Walworth, and the demolition of the Heygate became a major factor in the plans. The existing flats now fall short of the government's 'decent homes' standard and will be replaced by approximately 6,000 new homes. By the summer of 2010, 99% of residents had left, many being re-housed locally, some in the surrounding boroughs. One famous former resident was boxer Lloyd Honeyghan who won the World Welterweight title in 1986. The Estate today has a steady stream of photographers visiting to document its demise and film crews have used it as a back drop in films such as *Harry Brown* which starred one time local, Michael Caine.

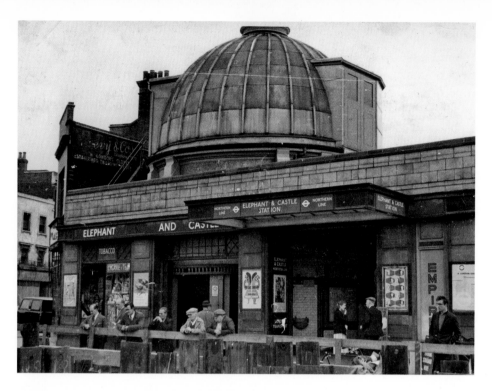

Elephant and Castle Tube Station *c.* 1958

Designed by Thomas Phillips Figgis and built in 1890, the station has been modernised and rebuilt over the years, with its final incarnation unveiled in 2003. It services both the Bakerloo and Northern tube lines. The first baby born on the underground system was born at this station in 1924. Reports at the time claiming she was named Thelma Ursula Beatrice Eleanor, thus spelling TUBE, were later proven to be false, with her real name being Maria Cordery.

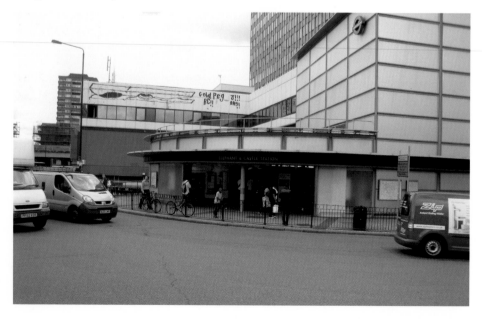

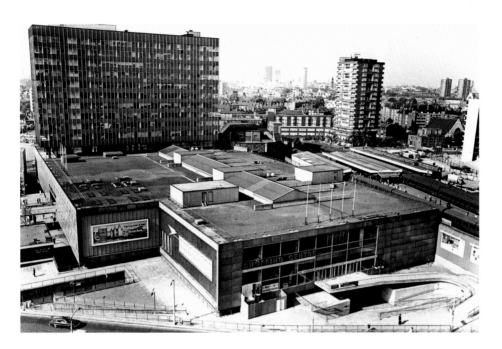

Elephant and Castle Shopping Centre *c.* 1970

Once know as 'The Piccadilly of the South', the 'Elephant' was famed for its music halls and fine drapers, lost to Second World War bomb damage. Plans were drawn up to revitalise the area, with a shopping centre seen as the crowning glory. The architects, The Willett Group were chosen to design it and in March 1965 it duly opened as Europe's first covered shopping complex, which incorporated 115 retail units and the eleven-storey office block, Hannibal House. Within a few years, the shopping centre was seen as out-dated and a general eyesore. Various schemes over the years have tried to revive it, in 1999 the entire building was painted red in aid of Comic Relief. However, its heyday has long since gone and it is due for demolition as part of the regeneration scheme for the area.

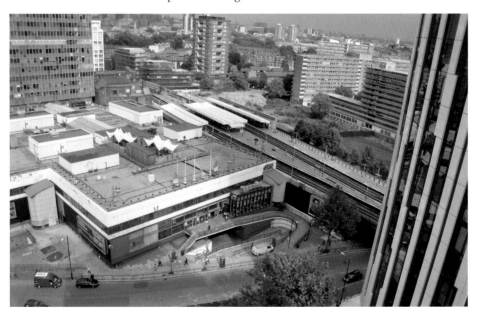

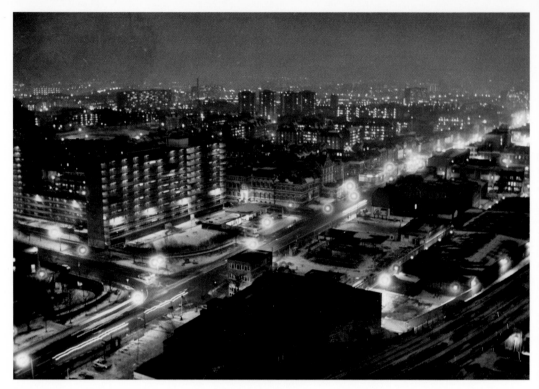

View at Night from Draper House
c. 1987

The tallest block of residential flats in London when completed in 1965, Draper House was named after the Drapers' Company who built almshouses in the area as far back as the 1650s. The block has 133 flats and stands 25 storeys in height. In the photograph above, the Heygate Estate, seen here with its lights blazing (far left) dwarfs the other buildings in the vicinity. As part of the new regeneration project agreed in 2010, 6,000 new residential properties are planned to be built over the next few years in SE17. The tiered South Central East and West housing developments, which were completed in 2006, can be seen in the forefront of the photograph to the left.

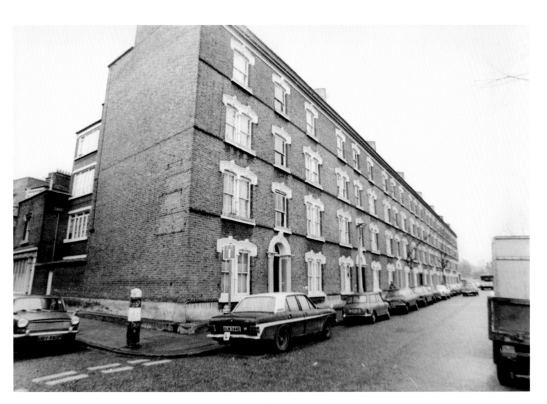

The Pullen Buildings *c.* 1978
Local builder James Pullen & Son built the estate over fifteen years from 1886 to 1901. A couple of the original twelve blocks were destroyed in the Second World War, others demolished to make way for new housing estates during the 1970s. The surviving buildings are some of the last remaining Victorian tenements in London and now form part of a conservation area. In 1899 the tenants paid 8 shillings per week for three rooms, which included a scullery and a kitchen. An extra 6 pennies were charged for the gas supply and cleaning of the stairs. Ground floor properties had access to the work yards that adjoined the buildings. In the late 1970s Southwark Council planned to demolish the rest of the buildings, but a combination of existing residents and squatters fought a campaign to save them. Around half of the flats are now owned privately.

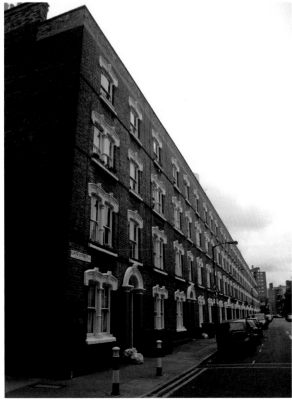

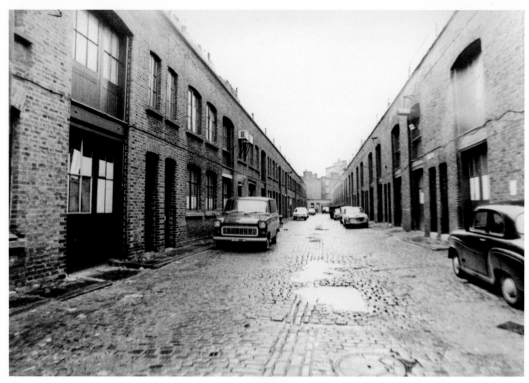

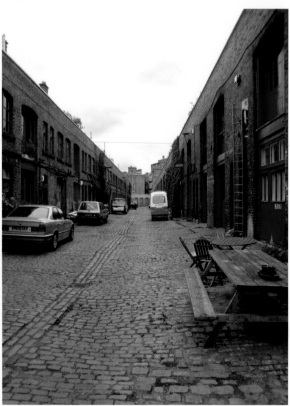

The Iliffe Yard c. 1977

As part of the 'Pullen Building' project undertaken by local builder James Pullen, purpose built work yards were constructed alongside the original 650 flats built in the late nineteenth century to comprise small work shops where the likes of seamstresses, candle makers, hansom cab drivers and other tradesmen could work. Clement and Peacock yards were also constructed and are still in use. After years of neglect by Southwark Council, new craftsmen moved in, comprising painters, silversmiths, ceramacists, bookbinders and filmmakers amongst others. Open days are held every year at the yards, where members of the public can visit the studios and buy directly from the artisans.

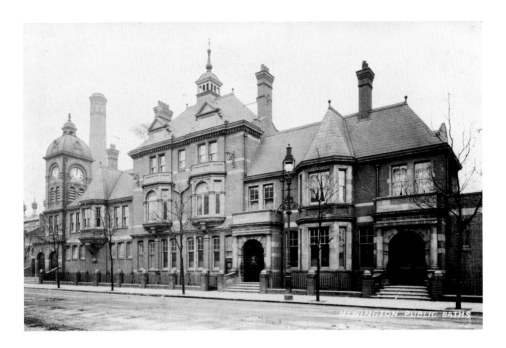

Manor Place Baths c. 1910

This Grade II listed building was opened on 16 March 1898 built at a cost of £60,000 from a design by E. B. I'Anson. It contained a public washhouse, a laundry and swimming baths. Generations of Walworth residents used the facilities, encouraged to do so to maintain personal hygiene. As well as a swimming venue, the halls were used for civic and social functions as well as staging other sporting occasions with boxing particularly popular, both amateur and professional.

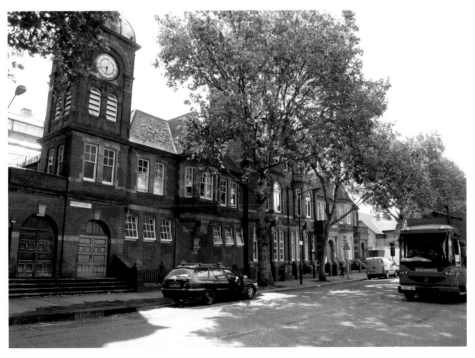

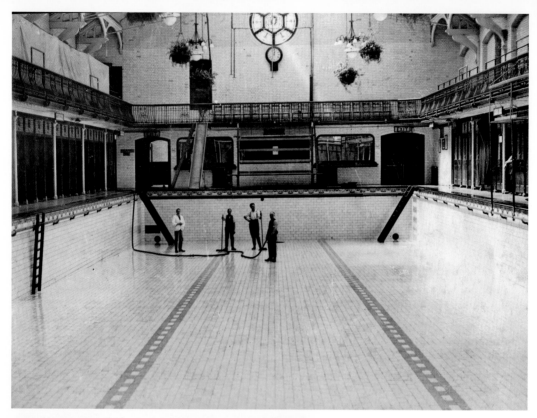

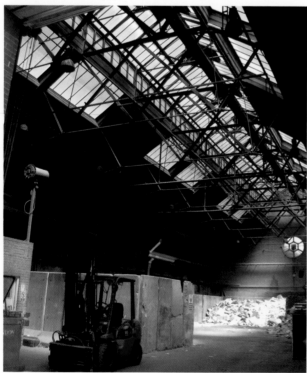

Manor Place Baths *c.* 1935
There were three pools in total
with an average length of 40
yards each. Manor Place closed
in 1978 with Southwark Council
citing cracked and dangerous
baths as the main reason. A new
swimming pool at the nearby
Elephant and Castle Leisure
Centre would eventually replace
them. Since 2007, parts of the
building have been home to the
London branch of the Buddhist
group Kagyu Samye Dzong. The
pool in the photograph above
is now used as a recycling yard.
The stained window at the back
of the hall, also seen above,
is still intact and the clock on
the front of the building keeps
excellent time.

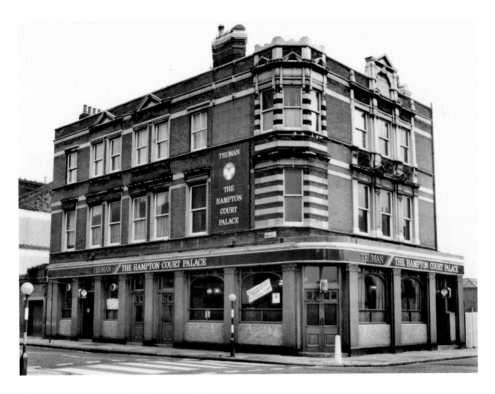

The Hampton Court Palace *c.* 1978

This imposing and impressive mid nineteenth century pub, with its name stone carved at the highest point of the building, once had a hall that could seat 100 for dinner. Members of the 'Odd Fellows' societies of the day would regularly meet there. Somewhat off the beaten track, it is situated near the Newington Estate, at 35 Hampton Street. Over the years it has had a fine reputation for its food and the live entertainment it provided with a succession of singers and bands performing the hit songs of the day on most nights. The house band went by the name of The Swinging Hamptons.

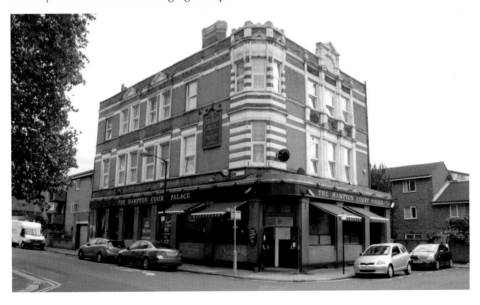

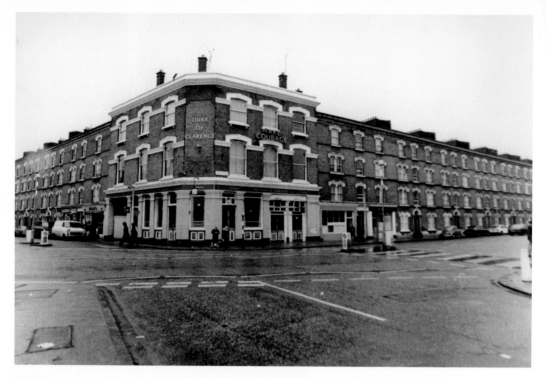

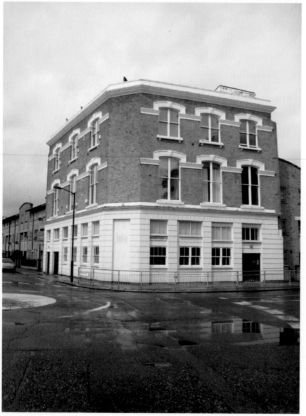

The Duke of Clarence c. 1978
In 1895 this was the home of 'The Lynn', Britain's oldest surviving amateur boxing club, which started in 1892 and continues to this day, now based in nearby Camberwell. The Duke of Clarence stood at 154 Manor Place, on the corner of Penton Place. In 2005 the pub became private housing known as Duke of Clarence Court. The buildings either side of the pub in the photograph above were part of The Pullen tenements, demolished to make way for the Duke of Clarence Yard Estate. The Nor Fisheries shop, seen to the right above, was infamous for having a policy of selling bags of chips only if bought with a piece of fish.

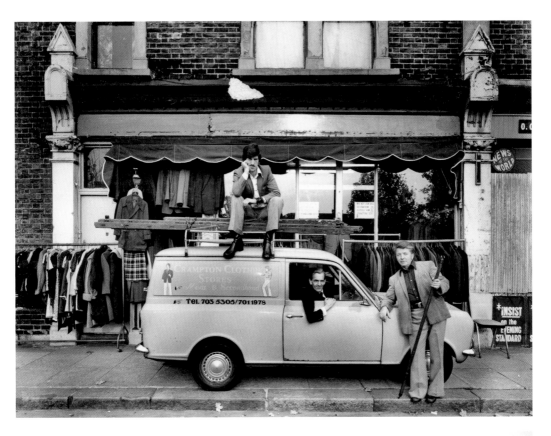

Crampton Street c. 1975

A street that has undergone massive changes over the past few years. On one side, the Pullen flats, the Electric Elephant café/gallery selling art created in the nearby yards and workspaces and the Fare Shares Food Co-operative shop at number 56. Directly opposite, there now stands the 'O-Central' housing development which was completed in 2008. The 'topping out' ceremony was undertaken by the then England football captain John Terry, who stated he had begun adding property from the Walworth area to his property portfolio. The Kennington and Walworth Royal Mail delivery depot is at the Manor Place end of Crampton Street.

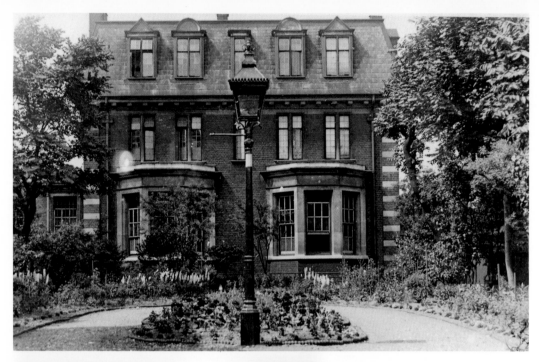

Carter Street Police Station, Carter Place c. 1931

Over 200 years ago, this was Keen's Row, with Walworth House its largest property which had a long front garden. Subsequently this became home to a Dr Carter, who later gave permission for Carter Street to be constructed on the land. Walworth House was later rebuilt but the garden was left and it can still be seen to this day from the top deck of any passing bus. The police service bought the lease in 1856 and it became Carter Street police station. In 1993 they moved to a modern purpose built station at number 12–28 Manor Place. The famous blue lamp from the aforementioned garden now stands outside the newly named Walworth Police Station.

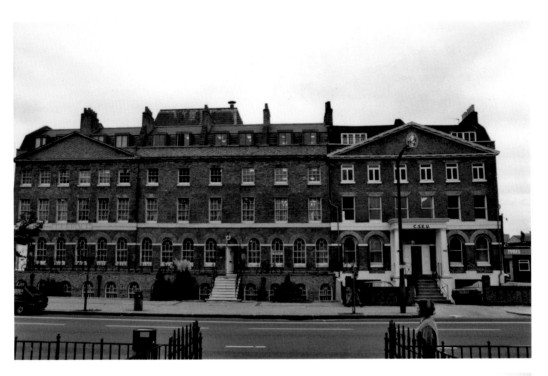

The Terrace c. 1980
Grade II listed group of
buildings built between 1793
and 1799 and attributed to
architect and surveyor Francis
Hurlblatt. Made in yellow stock
brick with a slate roof, there
is a fine oval plaque above
number 142 depicting a woman
draped with flowers. These
were once the houses of the
well-to-do families of Walworth.
The development underwent
extensive renovation in
1978, with the main building
becoming the Labour Party
Headquarters, known as John
Smith House in honour of
the party's late leader. The
pediment at 142, which housed
the Confederation of Ship
Building and Engineering
Unions, was added in 1978.
Southwark Council had
offices here until recently, but
currently these grand buildings
stand empty.

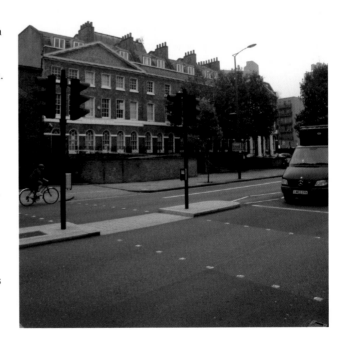

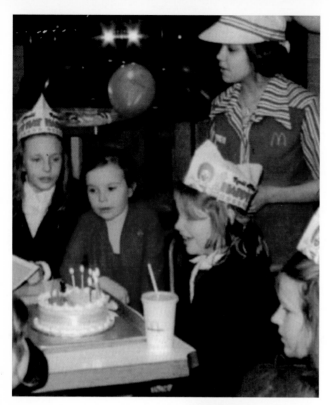

198–202 Walworth Road
c. 1980

In 1779 the Cuming family moved to number 3 Dean's Row, Walworth. Here, Richard Cuming began his life-long collection of artefacts that eventually became known as the Cuming Collection, part of which is housed at The Cuming Museum in the old Vestry Hall building. On the site of Dean's Row today stands a branch of the chain McDonald's, which opened in 1981 and soon became a very popular venue for birthday parties for local children. The company began in the USA in 1940 and opened its first UK outlet in Woolwich, South London, in 1974. However, with Eel, Pie & Mash shops in operation from the early 1900s, the phenomenon of 'fast food' was nothing new to Walworth.

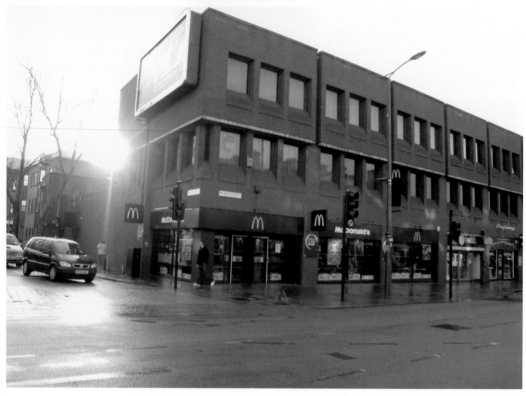

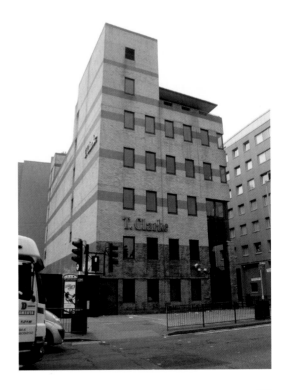

116 Walworth Road *c.* 1890

The Hanover photographic studio was established here in 1865. Nye & Co. then took over the premises before the business was bought by Lambeth born photographer Henry Bown in 1906. The Bown family owned various establishments in South London, including one in nearby New Kent Road. At number 116 now is Stanhope House, the headquarters of T. Clarke, who are currently working on the 2012 Olympic stadium in Stratford, east London, as the main electrical contractor.

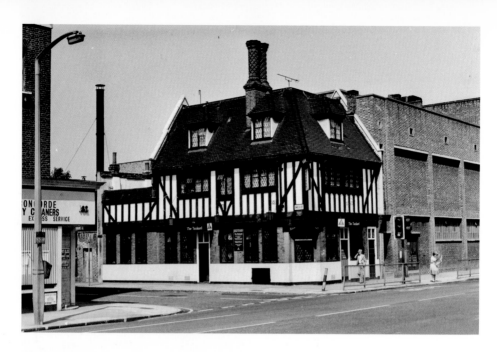

The Tankard Public House *c.* 1975
A mid nineteenth century mock Tudor pub situated at 178 Walworth Road on the corner of Amelia Street. A welcoming design with especially beautiful red brick chimney stacks. The Tankard was well used by many local newly-wed couples in years gone by for their wedding receptions, following marriage ceremonies conducted at the old town hall across the road at number 157.

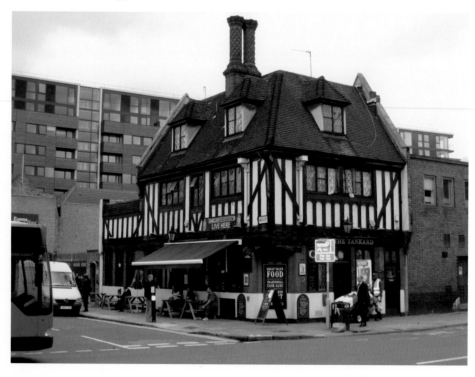

The King's Head Pub
c. 1980
Formerly at 204
Walworth Road, a
pub had stood here
for well over two
hundred years. It was
rebuilt in 1880, and
its first floor assembly
hall held lectures and
concerts. Tiles inside a
doorway once depicted
a drinking scene from
Shakespeare's *Henry
VIII*, and exterior tiled
plaques advertise
Watney Ales and
Reid Stout. In its
last years as a pub,
it was renovated and
became Monaghan's
bar for a while and has
been a William Hill
bookmakers since 2008.

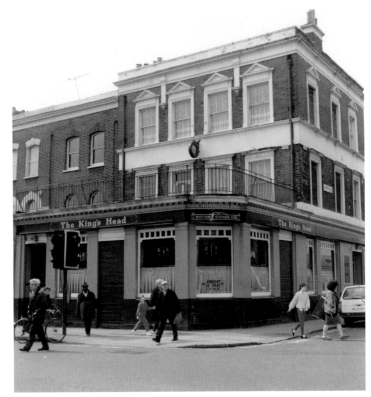

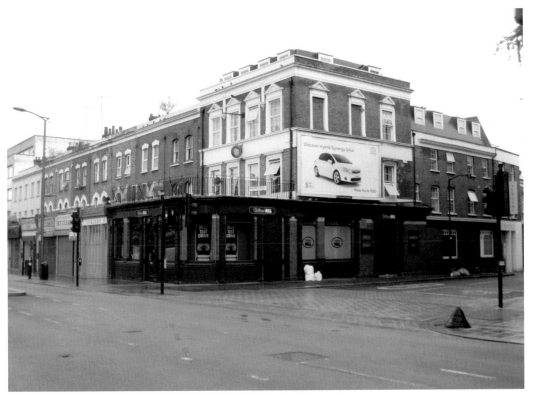

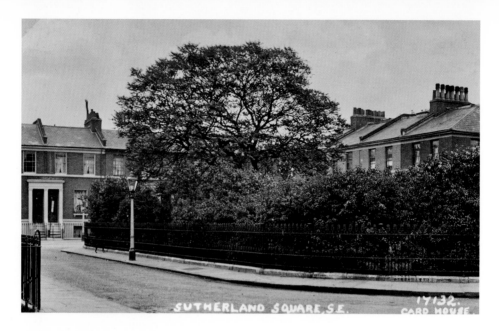

Sutherland Square c. 1916

Tucked away to the west of the Walworth Road are these early to mid nineteenth century Victorian houses that form the charming Sutherland Square. The Square and its surrounding streets are now much sought after properties and they form the Sutherland Square Conservation Area which also covers parts of Fielding Street, Carter Street and Lorrimore Road and Square. This picturesque part of SE17 particularly shows the diversity of buildings within Walworth.

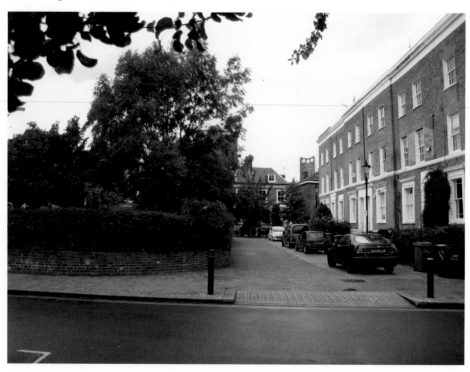

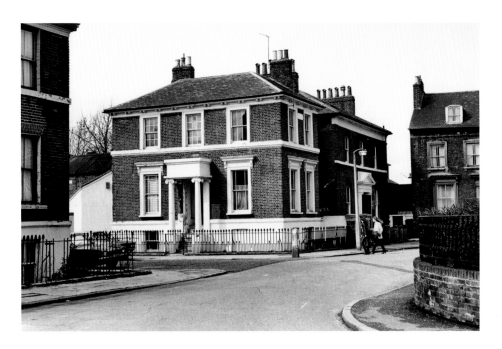

Sutherland Square *c.* 1978

At the heart of the square is the communal residents' garden. The making of 'garden squares' was very popular in central London and was meant for the use of the inhabitants of the surrounding houses. Many of the houses suffered from neglect in the latter years of the twentieth century but many have now been restored to their former glory, fronted by their cast iron black railings.

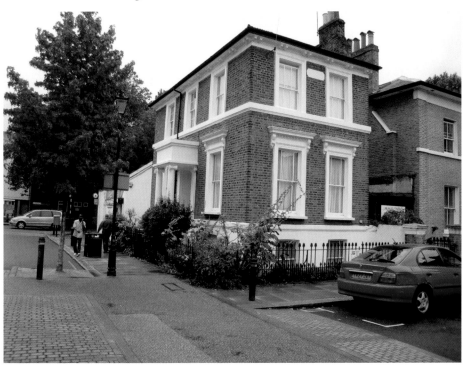

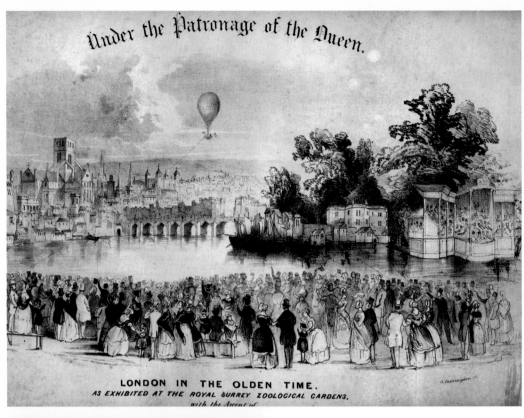

Under the Patronage of the Queen.

LONDON IN THE OLDEN TIME.
AS EXHIBITED AT THE ROYAL SURREY ZOOLOGICAL GARDENS,
with the Ascent of

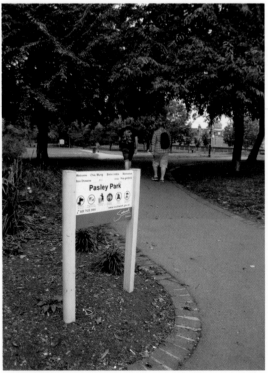

The Royal Surrey Zoological Gardens
c. 1850s

Opened in 1831 by Edward Cross on the grounds of the Manor House, the 15 acre gardens with 3 acre lake was designed by Henry Phillips. A glass conservatory, 300 feet in circumference, housed cages where lions, tigers, giraffes, exotic birds and elephants amongst others could be observed. Panoramas depicting the eruption of Vesuvius and the Great Fire of London were accompanied by firework displays near the lake. Queen Victoria visited with her family in 1848. By 1856 the popularity of the zoo was in decline and the grounds were sold at auction. The new owners built the Surrey Music Hall, which held 10,000 people. Later, for a short period, this was the temporary home of St Thomas' Hospital until 1871. Finally the land was sold to developers in 1872 and was soon covered in rows of terraced houses. Pasley Park stands on a small part of this land today.

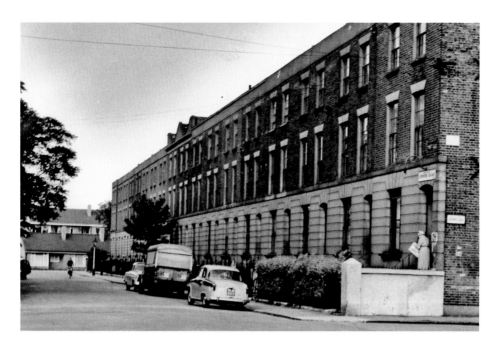

Lorrimore Square/Road *c.* 1955

A map of Walworth from 1681 shows a common called 'Lattamore' or Lower Moor; 19 acres in size, that today is the location of Lorrimore Square. In 1769, Henry Penton leased the land from the ancient Dean and Chapter Estate. Records show it was grazing land up until 1831. House building began in the area around 1856. Today the houses on the eastern side of the square fall within the Sutherland Square Conservation Area.

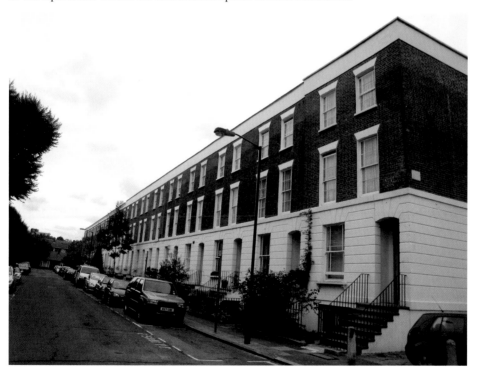

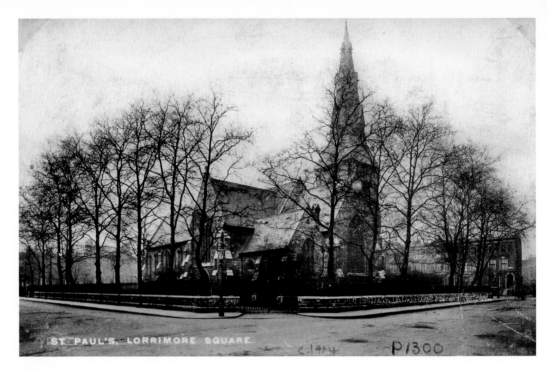

St PAUL'S. LORRIMORE SQUARE c.1914 P/300

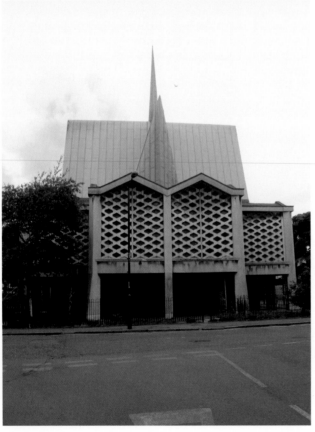

St Paul's Church c. 1914
The original church was designed and built by Henry Jarvis in 1856 in a style described as Victorian Gothic. The church, located in the centre of Lorrimore Square, was surrounded by houses constructed around the same time. In 1940 it was hit by a succession of incendiary bombs during an air raid, which left only the steeple standing. A new St Paul's was built from 1959 to 1960 designed by architects Woodroffe Buchanan & Coulter and this building is now Grade II listed. Stone from the original St Paul's was used in the new construction. It has a timber roof, clad in green copper, with stained glass windows by the company Goddard & Gibbs.

St Wilfreds c. 1950s

Situated at 97 Lorrimore Road, this imposing structure was designed by Frederick Arthur Walters (1849–1931), a Scottish architect noted for his work on over fifty Roman Catholic churches. The clergy house at the English Martyrs Church on Rodney Road is also the work of Walters. St Wilfreds was built in 1914 in 'perpendicular gothic' style in red brick with a 60-foot tower topped by a small spire. It was bomb damaged in November 1940, and restored between 1948 and 1949.

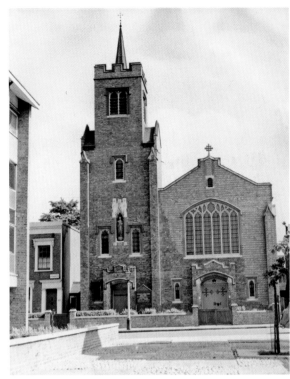

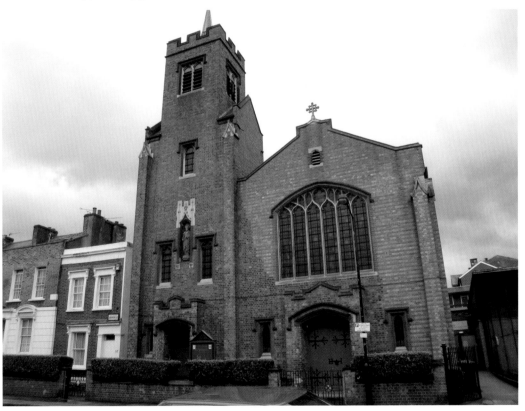

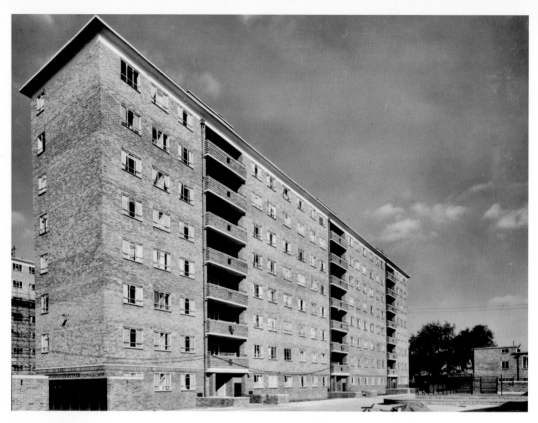

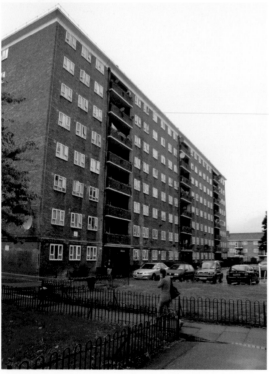

Penrose House c. 1965

The Penrose and Carter Street areas of Walworth were badly damaged by the V1 flying bombs in 1944. At one point 100 'Doodlebugs', as they were nicknamed in Britain, were being fired at the south-east each day, causing mayhem among the tightly packed rows of terraced houses below their flight paths. The bombings led to the deaths of forty-three people in SE17 and left hundreds more injured. Penrose House rose in this area in 1965 comprising of two, eight-storey blocks and four, three-storey blocks totalling approximately 190 flats, complete with tenants' hall on site. Penrose Street was originally called West Lane and stands opposite East Street, better known locally as 'East Lane'.

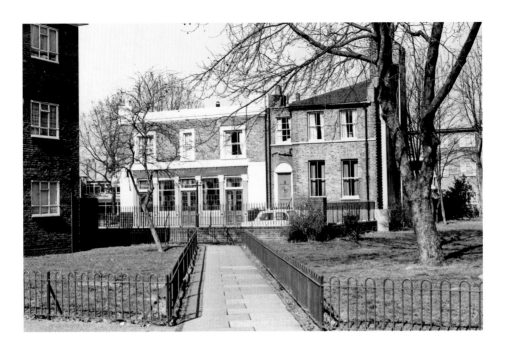

The Beehive Pub *c.* 1977

In 1796 the newly formed Montpelier Cricket Club played their first match at the Montpelier Tea Gardens in Walworth, moving in 1808 to The Beehive Tea Gardens which this pub once looked out onto. The Club remained there until 1844 when property developers purchased the land and it moved to the Kennington Oval, then a market garden owned by the Duchy of Cornwall. Thus, members of this gentlemen's cricket club were instrumental in forming what is today known as Surrey County Cricket Club. The Beehive Pub is at 60–62 Carter Street, and has a good reputation for its food and the art on the walls.

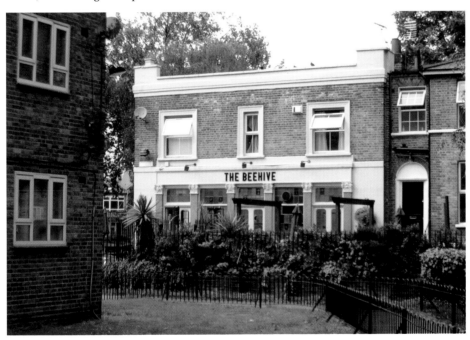

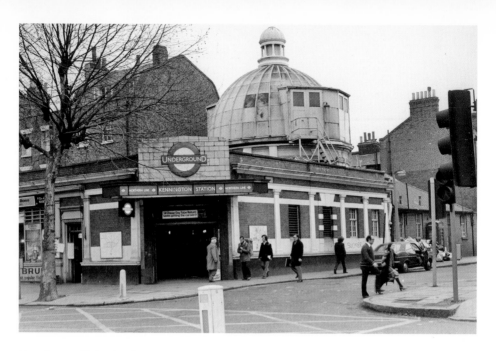

Kennington Tube Station *c.* 1978
Built in 1890 and standing on the corner of Kennington Park Road and Braganza Street, this the last station of the original City and South London Railway layout still resembling its original design. The dome once housed a hydraulic lift and two new platforms were added in 1926. It recently underwent a thorough renovation, the first in over eighty years, with its distinctive tiles reproduced by the company Craven Dunnill Jackfield.

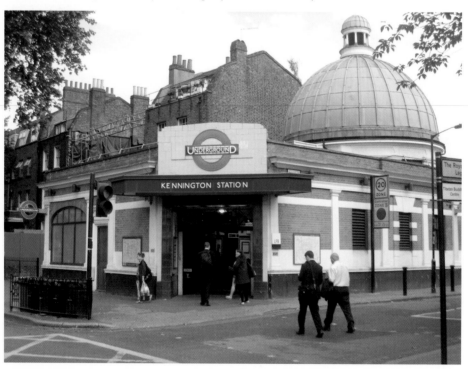

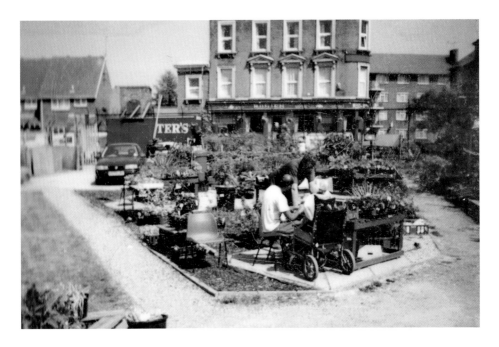

Walworth Garden Farm *c.* 1987

The farm began in 1987, with local people transforming derelict land into an oasis of flowerbeds and fruit and vegetables. It is a registered charity that now provides NVQ training in horticulture for the unemployed, as well as interacting with local schools and people with learning difficulties on various projects and even running bee-keeping classes using the custom built apiary. The farm can be found on the corner of Braganza Street and Manor Place. The pub standing in Delverton Road at the back of both of the photographs was once called The Surrey Gardens Hotel and is now known as Bison.

www.walworthgardenfarm.org.uk

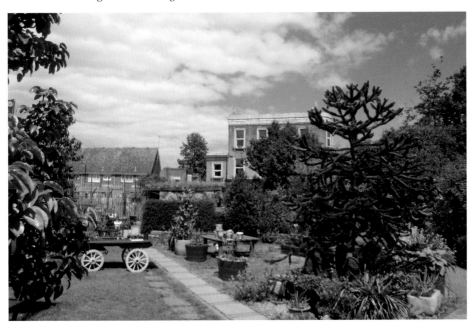

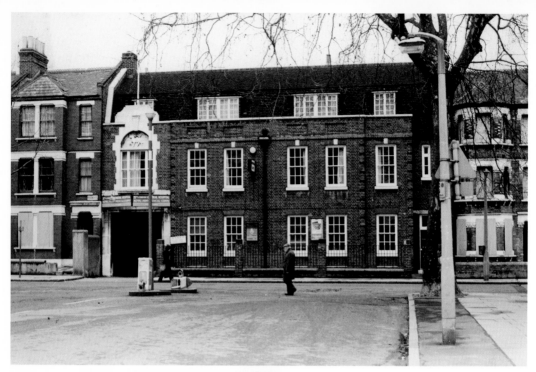

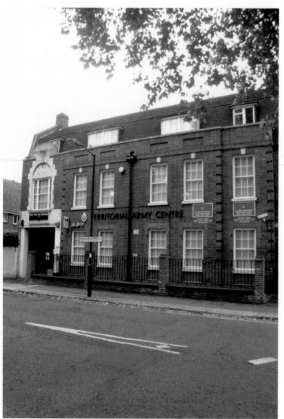

Territorial Army Centre c. 1977
Situated at 71 Braganza Street, the
Walworth TA centre is home to A
Squadron – General Support Medical
Regiment – RAMC, which is part
of the 256 Field Hospital. Some of
its members are currently serving
in the Afghanistan conflict. It's also
home to the army cadets of the 73
and 75 detachment. The Surrey Rifle
Volunteer Corps were once based
here, and they later amalgamated into
The Queen's Royal Surrey Regiment,
so named in 1661 in honour of
Catherine, Infanta of Portugal who
became Queen Catherine of Braganza
after marrying King Charles II in
Lisbon in 1662. The Paschal Lamb, the
badge of the regiment, is stone cut
into the white arch on the left of the
building.

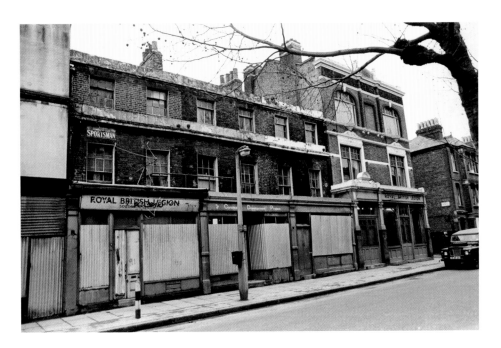

The British Legion Club *c.* 1978

The British Legion started in 1921 and its aims were to provide care, support and to campaign on behalf of ex British Armed Forces personnel and their families. It was granted a royal charter in 1971 to mark its 50th anniversary and is best known for its Poppy Appeal each year. The members only social club at 34 Braganza Street is on the corner of Gaza Street and is on the site of an ex pub called The Royal George, having moved from a couple of doors along from the left in the 1980s. Those buildings have now been demolished and the Kennington Enterprise Centre now stands on that land.

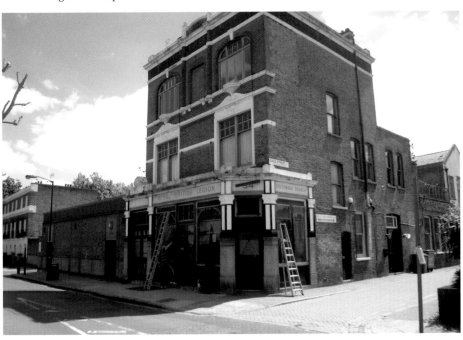

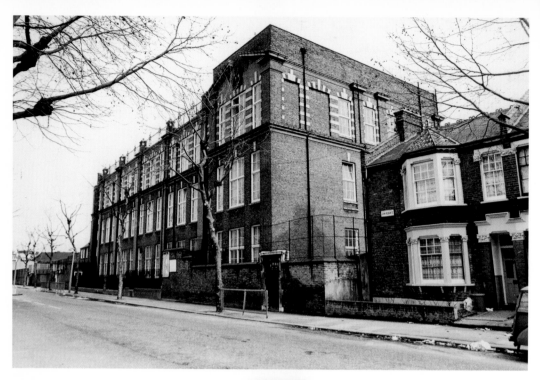

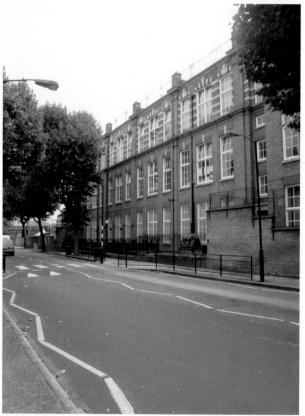

John Ruskin School *c.* 1978
This London School Board
school is on what was formerly
Beresford Street, and which later
changed its name to John Ruskin
Street in 1937 in honour of
Ruskin, who as a prolific writer
and respected art critic, became
very influential in the Victorian
era. John Ruskin Infants school
is also named in his honour. The
Ruskin family had attended the
Beresford Street Chapel, built for
a Dr. E. Andrews in the 1820s,
and it was in use up until 1923.
Ruskin had also studied at the
Young Gentlemen's Academy
on the Walworth Road on a site
now occupied by the Kwik Fit
company. The London School
Board was set up in 1870 to build
and run schools in the poorest
areas of London. Another noted
local lad, Sir Michael Caine,
attended the school in 1936.

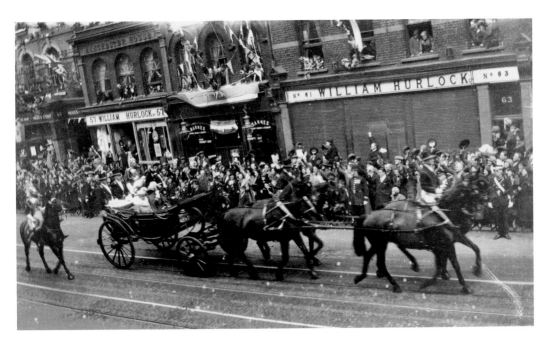

Royal Visits to Walworth 1935/1993

Crowds line the Walworth Road for the visit of King George V and Queen Mary on the occasion of their Silver Jubilee on 18 May 1935. Almost sixty years later, the late Princess of Wales opened the River Point Hostel for single homeless women in Manor Place on 10 March 1993. The Princess was challenged to 'gimme five' by local Walworth Road resident and well-wisher Danny Walters, resulting in footage that made the national news.

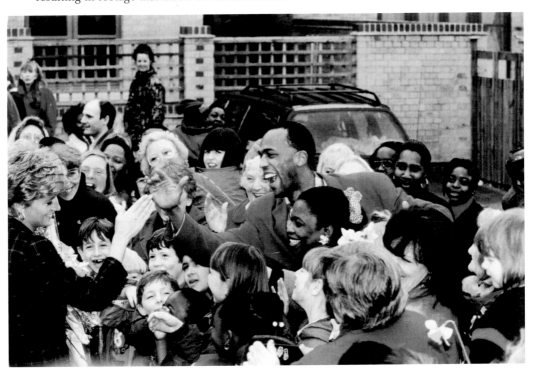

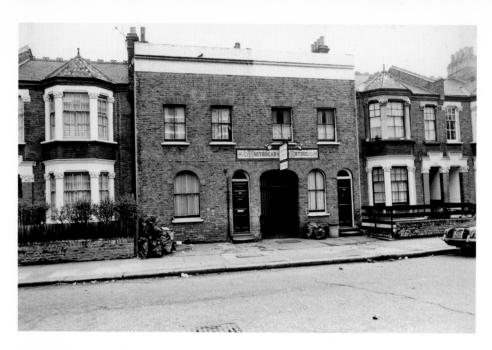

The Whitbread Mosaic *c.* 1978

This fine example of mosaic work is found on a wall approximately half way down John Ruskin Street on the South Side. It was formerly the rear entrance to the Grosvenor Tavern, the front being on Grosvenor Terrace, SE5. Both back and front are now houses. John Ruskin Street is so long that it begins in the SE5 postcode at its Walworth Road end, becomes SE17 in the middle, before returning to SE5 at the Camberwell New Road end.

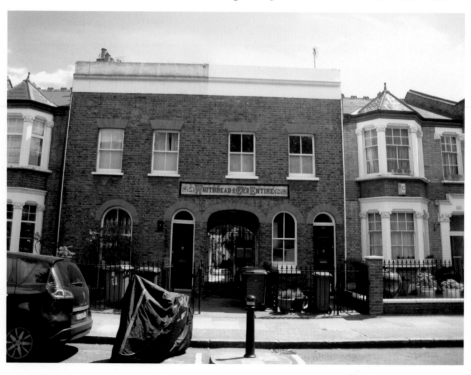

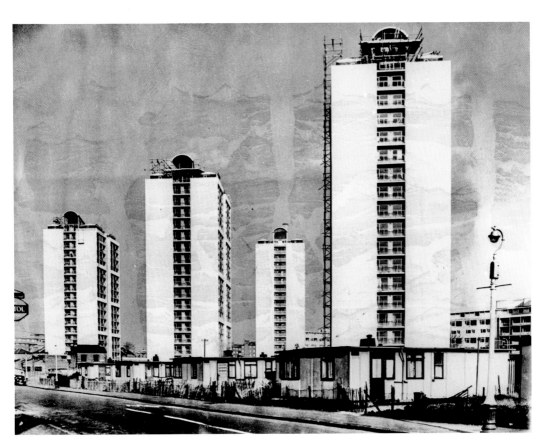

The Brandon Estate c. 1961

Named after Thomas Brandon, a late eighteenth century land developer in the Walworth area, and designed by E. Hollamby for the London County Council, this was one of the first high rise developments in London. It contains six eighteen-storey and five twenty-five-storey blocks, a public library, a shopping precinct and a doctors' surgery. The tusk of a prehistoric mammoth was discovered when excavating began and is now displayed at the Cuming Museum. The Henry Moore statue 'Two Piece Reclining Figure no.3' from 1961 is situated on a small hill near to the Molesworth House block. English Heritage has suggested the estate be classified as a conservation area, in respect of the 'outstanding re-development scheme'. Temporary 'pre-fab' accommodation can be seen at the foot of the newly built blocks in the photograph above, which highlights the changing cityscape at the time. The estate today is often used for filming, with the cast and crew of *Doctor Who* recent visitors.

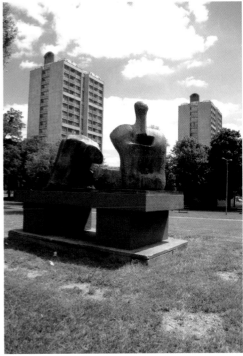

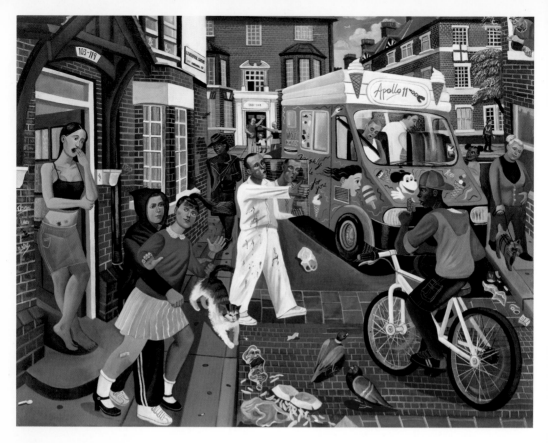

Apollo 11 by Ed Gray. A painting of Liverpool Grove, used by kind permission of the artist.
www.edgrayart.com

Acknowledgements

Darren Lock is from a family of East Lane market traders and has been collecting photographs of the area for many years. He dedicates his work on this book to his Mum Nelly.

Mark Baxter is from 'over the border' in Camberwell SE5, and is proud to be from a long line of 'totters'. He dedicates his work on this book to his Mum Jeannie.

Both authors would like to thank all the people who donated photographs for the book, especially the members of the 'Walworth – Now and Then Group', bless you x.

Also many thanks to Lisa, Lou and Sharon, Sarah and all at Amberley, Stephen and the staff at Baldwin's, Roy, Cheryl, Lorraine and staff at Arment's, Catherine and Alan at St Peter's, Charlotte at Inspire, Paula and the staff at the Local History Library, Sue at Surrey Square School, Morganic, Ed Gray, Martin and Dave at Peckham Rye, David Buckley, Alan Edwards and Kevin and staff at Walworth Garden Farm. We also doff our flat caps to the late Mary Boast, Stephen Humphrey, Len Carter and Michael Collins.